collage

Women of the Prix Pictet since 2008

collage

Women of the Prix Pictet since 2008

gestalten

Contents

Preface

It is a particular honour for me to introduce this book on the Prix Pictet's women photographers. I do so with a sense of humility. As the first female managing partner in the Pictet Group's 217-year history, I am acutely conscious of the pioneering achievements of women both in business and the arts.

When we founded the Prix Pictet in 2008, our profound hope was to play a part in raising awareness of the world's most pressing environmental and social issues through the medium of photography. Our founding President, the late Kofi Annan, was quick to grasp the potential of the Prix Pictet. 'Communication has become essential,' he said, '… and photography is probably the most effective because it is immediate and instantaneous. It is critically important to ask artists to use their creativity to address the immense challenges we face.'

At the time, the word sustainability was hardly heard in the art world. Across the continents, there were a handful of museums and galleries dedicated to such photography, but things have changed in the last 14 years. The issues arising from the spiralling sustainability crisis are now at the forefront of the global debate, both inside and outside photography. They are of central importance for organisations and individuals alike.

Ironically, while image-based mobile apps have made photographers of us all, the status of photography as a creative endeavour has grown. It is now regarded as the great democratic art form of our age. In all of this, the Prix Pictet has held a leading role, presenting, over its nine thematic cycles, images of rare power and surpassing beauty. Each cycle has addressed critical issues of global sustainability in inventive and engaging ways.

Just as the status of photography has risen, so too has the participation of female photographers in the award. From one cycle to the next, more women are being nominated and shortlisted. In fact, three of the past four laureates have been women.

The fifth of the United Nations' 17 Sustainability Development Goals states, 'ending all discrimination against women and girls is not only a basic human right, it is crucial for a sustainable future; it is proven that empowering women and girls helps economic growth and development'. In our own field of finance, we are seeing an encouraging gain in the number of women in senior decision-making roles. Together with my fellow managing partners, I consider this to be not only an essential investment in talent but also a commitment to fresh perspectives, which are vital in powering the sustainable businesses that will cater for our future needs.

So, 14 years after the launch of the Prix Pictet, this book is a timely reminder of the special qualities of the 1,200 exceptional women photographers nominated for the award to date. As you turn these pages, it will quickly become clear that women photographers have immeasurably enriched the award. This book is a tribute to their work.

Elif Aktuğ
On behalf of the Pictet Managing Partners

Introduction

There is nothing new about women and photography. Among its earliest pioneers was the English botanist Anna Atkins, who, in 1843, became the first person to publish a book illustrated with photographic images. This was followed by the early artistic experiments of Julia Margaret Cameron and Virginia Oldoini. But for most of photography's 180-year history, women practitioners have been a small minority – and overlooked at that. Indeed, women have more often been in front of the lens than behind it. Yet, as the photographer Eve Arnold famously said, 'I do think that women think differently and have something to offer that men don't have'.

Our first Prix Pictet shortlist in 2008 included Lynn Davis, Mary Mattingly and Susan Derges, outstanding photographers within an otherwise male cast, and each with their own unique style. Since then, women have been increasingly represented in our shortlists, but we did not have our first female laureate, Valérie Belin, until 2015. After that groundbreaking moment, Joana Choumali (2019) and Sally Mann (2021) won the award. Yet, this is only part of the story.

Of the thousands nominated for the prize, fewer than 120 artists have reached the shortlists. This book allows us to reflect, widen our vision a little and place the work of women photographers in the spotlight. We invited all of the women nominated for the prize since 2008 to submit recent work on the broad theme of photography and sustainability. We then worked with a guest editor, Fiona Shields (Head of Photography at *The Guardian*), to make our final selection.

In some cases, such as Tomoko Kikuchi's photographs of funeral performers in rural China, shrouded in neon light, they reveal their secrets slowly. Others are more direct, with themes ranging from global catastrophe – Rena Effendi's images of Irena Kovalenko amid the rubble of her Ukrainian home or Penelope Umbrico's technological waste – to the deeply personal, such as Diana Markosian's exploration of her mother's search for the American dream, and Georgina Goodwin's Covid-enforced moment 'with a new baby and a bubble of uninterrupted time'.

In her introductory essay, Jan Dalley, the *Financial Times*' Arts Editor and a regular member of the Prix Pictet jury, asks 'can we possibly identify such a thing as women's photography, or a female sensibility in the genre? Almost certainly not.' Yet, it is clear that women face particular obstacles to success. The legendary Mexican photographer Graciela Iturbide, in her interview for *Collage*, spoke eloquently of her need to escape first an overbearing father and then the strictures of marriage to pursue her muse and become a photographer, while at the same time caring for her young children. The result is a collection of some of the most iconic images ever made of Mexico and its people. 'It is,' she says, 'the photographer's job to synthesise and to make strong and poetic work from daily life.'

This book showcases women photographers of the Prix Pictet. Each of the 70 works featured in this book does exactly that. It is indeed strong and poetic work: a powerful collage and a beacon of inspiration for future generations of female photographers.

Isabelle von Ribbentrop
Executive Director of the Prix Pictet

Complicity – a conversation with Graciela Iturbide

MICHAEL BENSON

If she had had her way, Graciela Iturbide would have been a writer.

She still cites as influences writers like Emily Dickinson and the controversial Mexican social commentator Elena Garro who, she says, 'was one of the greatest writers of our times'. Yet, a literary career was an impossible dream. 'I was brought up in a very conservative family, but I always felt somewhat rebellious about that upbringing ... My father, who belonged to this bourgeois and conservative society, refused to let me study literature.' Still, try as he might, her father was unable to hide his own artistic interests. 'At the same time, he was an amateur photographer, and I slowly grew interested in the portraits that he took of us. He kept them in a closet, and I frequently stole them, despite the punishments that he gave me.'

Marriage at a very young age was her route away from parental restrictions and into photography. 'I married a liberal architect with whom I had the freedom to study cinema. Then I met Manuel Álvarez Bravo at school and became his assistant, which was crucial for my development as a photographer.' As her calling grew stronger, Iturbide realised that she needed a way out of her marriage 'to be able to dedicate myself to photography and film'. Not an easy road but a profoundly important one.

'My divorce caused a scandal. But when I got divorced, despite the fact that I had a good relationship with the father of my children, I felt liberated. I was able to do my jobs, both in photography and in film.' She never regretted or felt guilty about the breakup. As for her children, they were always with her, either in her small laboratory or on some of her trips. 'They loved that I was a photographer, and I shared all my work with them. I felt very happy to be myself, to be free, and to be alone. Photography was my passport; it enabled me to get to know my country and its native peoples.' Iturbide happily acknowledges the influence of Manuel Álvarez Bravo, Josef Koudelka, Diane Arbus and Francesca Woodman in the creation of her own special photographic language. 'They teach you; they help you grow as an artist.'

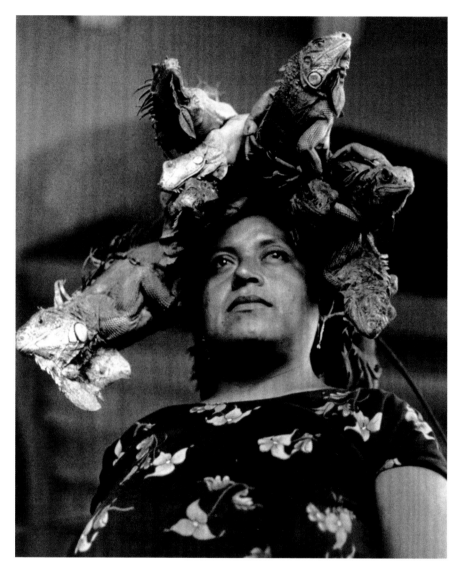

Nuestra Señora de las Iguanas, Juchitán, Mexico, 1979

In 1979, on the invitation of the artist Francisco Toledo, she followed in the footsteps of another group of her artistic heroes – Henri Cartier-Bresson, Sergei Eisenstein and Tina Modotti – and travelled to Juchitán, a small town in the southern Mexican state of Oaxaca. Here, she would make some of her most important work, in what she describes as a state of complicity with the indigenous Zapotec people. 'I was lucky that Francisco Toledo, one of our great artists, called me on the phone one day and offered me to do a job in Juchitán. He gave me two works of his to sell, and with the proceeds I paid for my trip and my material to work in Juchitán. When I arrived, since Francisco is from Juchitán and was deeply loved by the people, I arrived with his family. I fell in love with the personality of the Juchitecos, especially the women, I felt the love they had for me.'

For nearly a decade she was a regular visitor, immersing herself in the community, spending long periods of time with Zapotec women and cultivating friendships. Rather than merely documenting people from an outsider's perspective, Iturbide photographed her own interactions and encounters with the community. 'I need to be close to the people ... I need their complicity ... I learned so much about life from them.' Her Juchitán photographs highlight the culture's powerful women and *muxes*, men who identify as women, a third gender that has been celebrated since pre-Hispanic times. In Juchitec society, women hold significant political, economic and spiritual power. *Muxes* are similarly revered in Zapotec culture – they are believed to have special intellectual and artistic gifts.

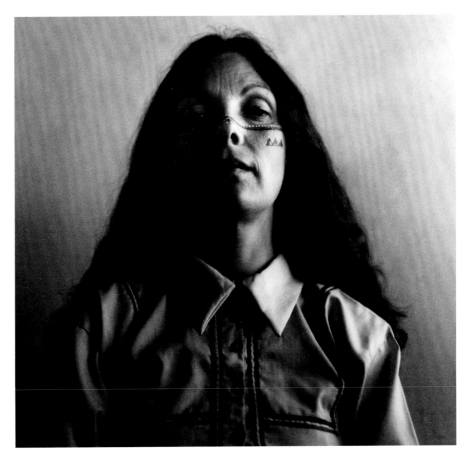

Autorretrato, Desierto de Sonora, Mexico, 1979

For Iturbide, 'the photographer's job is to synthesise, to make strong and poetic work from daily life'. The photographs she made with the people of Juchitán are some of her most lyrical and iconic. They include the famous *Nuestra Señora de las Iguanas* (Our Lady of the Iguanas), Juchitán, 1979, which expresses the independence of the community's women and their complex identities. This photograph depicts Zobeida Díaz. 'I spotted her in the Juchitán market. She was carrying the iguanas on her head and was planning to sell them. I asked her to wait a moment while I took a roll of 12 photographs. Only one or two negatives turned out well. The iguanas, an important cultural symbol of the Zapotec, encircle Díaz's head like a halo. It is an image of reverence for Zapotec women.' The people of Juchitán came to call this photograph the 'Medusa Juchiteca', because of its significance for them. 'They have made a sculpture of it in the town, and they make *huipiles* (traditional garments) with her image. I feel that this image wanted to fly, not because I promoted it – the town felt that it belonged to them.'

Nuestra Señora de las Iguanas is a strong and poetic celebration of the diverse cultural heritage of Zapotec women. It marked an important staging post in Iturbide's photographic journey. 'My first job as a photographer was to get to know my country and work with native peoples. From which I learned to know my country.' Only later did she begin to get to know the landscape and the objects that she found there. 'In the end, I am photographing birds, stones and volcanoes. I am coming to photograph the beginning of the world, curiously at the end of my life.'

Although not in a way she might have at first envisioned, Iturbide's childhood dream of a literary career was finally realised. By refusing to compromise and single-mindedly following the urgings of her muse, she has made a great poetic chronicle of the lives and landscapes of her Mexican homeland. ∎

All images are © Graciela Iturbide.
Courtesy ROSEGALLERY, Santa Monica

'The photographer's job is to synthesise, to make strong and poetic work from daily life'

GRACIELA ITURBIDE
Renowned Mexican photographer Graciela Iturbide has spent half a century capturing the beauty of her homeland. A recipient of the 2008 Hasselblad award, her work has been exhibited internationally, recently at Fondation Cartier, Paris, and is included in major museum collections, including The Metropolitan Museum of Art and Museum of Modern Art, New York, and Tate Modern, London. She continues to live and work in Mexico.

MICHAEL BENSON
is Director of the Prix Pictet and Founder of Photo London

Ciudad de México, 1969

Después del Rapto, Juchitán, Mexico, 1986

'Photography was my passport;
it enabled me to get to know my
country and its native peoples'

Magnolia, Juchitán, Mexico, 1986

Desierto de Sonora, Mexico, 1986

'I need to be close to the people ...
I need their complicity ... I learned
so much about life from them'

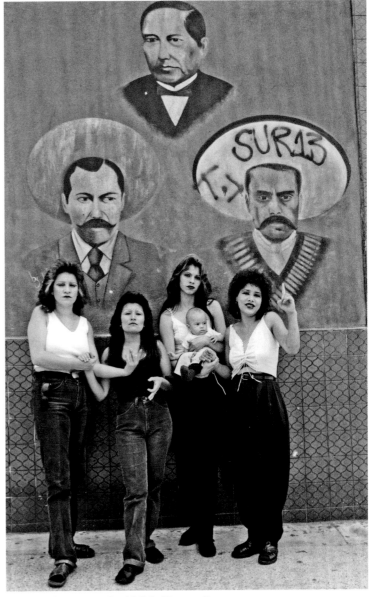

Cholas, White Fence Gang, East LA, United States, 1986

A strange and bitter crop

SALLY MANN

I was as surprised as anybody, maybe more surprised, to win the Prix Pictet, having been assured by a photo insider that nobody from the United States could win it.

He was looking at me with that 'You Ugly American' look, and I laughed and said, 'Especially a dumb, peckerwood southerner'. I wasn't really joking, but right now it's hard to be from anywhere in America, not just the South.

The work I submitted for the *Fire* edition of the Prix Pictet was taken, as almost all of my life's work has been, in my deeply troubled homeland of the southern United States. The writer Elizabeth Strout once said that we all have just one story to tell, and we tell it many ways. The story I've been telling for most of my artistic life has been largely about what it means to grow up in the American South, and, more particularly, what it is about the South that is both so alluring and so repellent. It's a deeply complicated subject, and far greater talents than mine have grappled with the fact that while the South is indeed magnolias and moonlight, not uncommonly has that moonlight illuminated some 'strange fruit' dangling from the branches.

Deep South, Untitled (Scrim), 1998

Of course, the question of race and the legacy of chattel slavery (the latter largely confined to the South) is the central issue dividing America today, one that has had a profound influence over almost every single aspect of our faltering republic. Over my career, I have chosen several ways to examine this, many metaphorical. But in 2008, I spent some time in southeastern Virginia tracing the route taken by Nat Turner on his ultimately failed slave rebellion.

His erratic and violent path through Southampton County led me directly to the Great Dismal Swamp, his intended hiding place, which is manifestly both those things: great and dismal.

Situated just 26 miles south of Old Point Comfort – the grotesquely ill-named spit of land where the first slave ship docked in America – the Great Dismal Swamp sprawls past the border of my native state, Virginia, and into North Carolina, occupying over 2,000 square kilometres. It's the size of a small country, say, in fact, Luxembourg.

Thick smoke billowed up ceaselessly, not just for days or weeks, but off and on for years. In some kind of poetic, metaphoric righteousness, even the soil itself burned

And 'dismal' hardly begins to describe the first impression imprinted upon the casual visitor. The American poet Henry Wadsworth Longfellow described it as a terrifying place 'where hardly a human foot could pass, or a human heart would dare'.

When my human heart dared and my human feet hiked through many miles of the swamp, I emerged with a record number of attached deer ticks – I quit counting at 40 – on every part of my body.

Those ticks, which took hours to find and remove, were only a small example of what the escaped slaves, who viewed the swamp as preferable to the living hell of enslavement, suffered when they fled to the rare and remote patches of high ground deep in the fetid swamp. Slithering with snakes, often venomous and deadly, the water bubbling with rotting plant and animal matter, the air thick with biting insects and the heavy foliage offering protection to panthers, bears and alligators, the swamp contained an enemy even greater to the Maroons – as escaped slaves were called – and that was the slave catchers and their fearsome dogs.

Angry owners and their hired, professional slave catchers, operating on the 'dead or alive' principle, sometimes surrounded the Maroon swamp communities and set fire to them, burning their quarry alive. For the inhabitants who refused to run from the flames, even death by fire was preferable to being returned to their owners and the excruciating punishments that would ensue.

But while the Great Dismal Swamp did provide refuge for the luckiest of these Maroons, it seems a fitting, apocalyptic end that a place so filled with pain should, a century and a half later, be devoured by an all-cleansing inferno.

By the time I was exploring it, vast fires, easily viewed from space, had begun consuming the swamp and continued to burn, forcing me to trespass around safety barriers warning of danger.

Thick smoke billowed up ceaselessly, not just for days or weeks, but off and on for years. In some kind of poetic, metaphoric righteousness, even the soil itself burned.

All of my homeland, the American South, smoulders as well, deep within itself. It is haunted by the still-glowing souls of the millions of African Americans who built this country with their hands and the sweat and blood of their backs. For years, I have been examining the racial history of the South, viewing the land as a vessel for the memories of the complex struggles enacted upon it. I move among ghosts, always aware of their presence.

Flannery O'Connor once said that the South is Christ-haunted, but I say it's pain-haunted, cruelty-haunted and death-haunted. And my pictures feel haunted sometimes too, the scenes coursing with the underground rivers of tears that Africans poured into the dark soul of their thankless new home.

One death in particular has troubled me since childhood, that of Emmett Till, a boy who was abducted, tortured and lynched while visiting family in Mississippi in 1955. So, a few years back, I set out to trace the route his murderers had taken in his last hours, beginning with the fateful wolf whistle he never whistled, in Money, Mississippi, passing along the Tallahatchie River and winding up on a balmy, serenely yellowish afternoon at the very boat lock from which 14-year-old Emmett was heaved into the river, naked, blinded, beaten, a cotton gin fan lashed with barbed wire to his neck.

Deep South, Untitled (Bridge on Tallahatchie), 1998

When I visited the site of his death, Emmett's murder was conspicuously unremarked upon (although recently my friend Maude Schuyler Clay, who lives nearby, sent me a picture of a sign that was erected on the newly cleared riverbank ... and immediately, typically, riddled with bullets).

So, anyway, I was lucky to have Maude, the granddaughter of the former owner of the land, to show me the exact site where his body had been discarded.

It was a trek, well off the road and isolated from any signs of life. But having pushed our way through the thick brush and scraggly trees to get to the riverbank, I was disappointed by the humdrum, backwashy scene before me. How could a place so weighted with historical pain appear to be so *ordinary*? Was there a photograph anywhere in this unalluring, scrubby brush?

I put on my photo-eyes and squinted into the hazy afternoon sun. With my hands I formed a rough 8×10-inch dimension, cropping out the old wringer washing machine caught in the vines upriver, imagining the sun breaking all the Kodak rules by milkily pouring into my wide-open lens aperture.

I set up the camera with increasing excitement. There was, in fact, something mysterious about the spot; I could see it and feel it, the spirit of Emmett Till, and hear the voices of myriad others like him, an irrepressible chorus of pain, humiliation and deferred hopes. When I released the shutter, I asked for forgiveness.

Maude drove with me the next afternoon on the dirt access roads alongside the cotton fields, mile after mile. We chatted as we drove, but as distracted as I was, I still slammed on the brakes when I saw the roughly human-shaped concrete mound off to the side of the fields.

'Oh,' said Maude airily, 'it's how they bury people out here in the summer.' And, sure enough, at the bulbous end of the mound were the remnants of one of those plastic funeral wreaths designed to be stuck into ground more yielding than this rock-hard clay.

I wondered who lay there and how they had come to be entombed with a gusher-load of concrete. Did this person die working in the cotton fields and then someone pragmatically called for a cement truck to pour a sarcophagus atop the body?

Out in the middle of nowhere, I contemplated this paradoxical scene so emblematic of the plucky, undiminished South. A no-frills monument to the intractability of the overworked soil and the practical, impoverished people who have long tried to wring a living from it.

Ever since my earliest years reading and writing about the South, I have tried to nail down just what it is that makes it at once so enchanting and so noxious, like fruit on the verge of spoiling. Ultimate beauty requires that edge of sweet decay, just as our casually possessed lives are made more precious by an indolic whiff of the abyss.

Deep South, Untitled (Three Drips), 1998

We southerners have come to believe, like Proust, that the only true perfection is a lost perfection, buying into our own myth of loss by creating a flimflam romance out of resounding historical defeat. In that nexus between myth and reality, we live uncomfortably, our cultural sorrows, our dumb kindheartedness, our blindness, our deliberate ignorance and our snook-cocking, renegade defiance playing out against a backdrop of profligate physical beauty.

That physical beauty is easy to find in the South, but what gins up the ecstasy is the quality of the light, the resonant, beating heart of that light, which is unique to the South. ▸

The landscape appears to soften before your eyes and becomes seductively vague, as if inadequately summoned up by some shiftless creator casually neglectful of the details.

Taking a photograph in these conditions is a challenge, even for modern film, and the resulting image often appears to have been breathed onto the negative; a moist refulgence within deepening shadows, details dissipating like those in a painting by Turner. I love that effect, and, with a hectic flush of near heatstroke as the humidity rises and the sun sinks, I load up my equipment, heading to the hills looking for it.

To whatever extent it is possible to photograph air, I am trying to do it, and to whatever extent photographs can reveal the dark mysteries of a haunted landscape, I will make them.

I am not alone in this search for a past impossibly present and the inescapable historical burden within it. It has been the wellspring not only for me, but also for the pantheon of visual and literary artists who emerged in the 20th-century South, from my friend and neighbour Cy Twombly to his friend Jasper Johns to William Faulkner, Robert Penn Warren, Eudora Welty, Tennessee Williams, Flannery O'Connor and the myriad heirs of the Southern Renaissance.

> ## To whatever extent it is possible to photograph air, I am trying to do it, and to whatever extent photographs can reveal the dark mysteries of a haunted landscape, I will make them

Choosing to work outside the art world's urban centres, as most of these towering figures have done, is difficult, or at least it certainly has been for me. But most of them, and especially Cy Twombly, managed and indeed benefited from this classical remove, employing the three words at the end of James Joyce's *A Portrait of the Artist as a Young Man*: 'silence, exile, cunning'.

Working as an artist in the South has never been easy. We tend to overreact with swaggering bravado, a screw-you

Deep South, Untitled (Mercuric River), 1998

lack of apology (with a commensurate lack of hypocrisy), an abiding belief in the elegiac myth of lost and enduring beauty and a persistence of vision, of self-examination that pierces the broken heart of our culture.

We also tend towards a fondness for bourbon. A journalist once asked William Faulkner about his drinking, and in response Mr Faulkner typed out his 'official rules of drinking':

'Summer: *Gin and tonic outside. Vodka tonic inside. No beer after sunset.*

Winter: *Scotch outside.*
 Whiskey inside.
 Bourbon either.
 No mint juleps after Labor Day.'

He signed off with: '*Hope that helps.*'

Even with the bourbon, it's a hard path for the southern artist. There is little interest from the large urban museums in artists who live in the South or do not live in a city. There is not a large collector base and the support and artistic fellowship found in the art-intensive cities is often not available to the rural artist. Living and working in the American South can be lonely and frustrating. As my friend the artist Billy Dunlap once remarked, the rest of the world seems to love us only when we act like characters out of a Tennessee Williams play.

Some of us are Blanche and some of us are Stanley, and God help us if we're Big Daddy, but, like all of those characters, as artists we're susceptible to myth and willing to use doses of romance that would be fatal to anyone else. In this respect, we are like the religious traditionalists of the Appalachians who handle venomous snakes without fear. What snake venom is to them, romance is to the southern artist: a terrible risk but also a ticket to transcendence.

Occasionally on my travels down South, I drew that ticket, moving in the slow motion of ecstatic time. In my revisionist memories, I hardly recall those hundreds of boring miles offering

no chance of a good photograph this side of the Second Coming. I have forgotten the many suppers of saltine crackers washed down with iceless gin, or the ballads (which even Emmylou Harris could not have made remotely non-milk-curdling) that I sang to keep myself awake on the highway, or the nights sleeping in the back seat of the Suburban while the windows of the neighbouring camper pulsed with blue TV light.

No, instead all that I remember is the rare, heart-pounding, brake-squealing lurch to the verge of the road after glimpsing a potential image.

My memories are of those euphoric moments of visual revelation, still fluorescing for me like threads in a tapestry in which most other colours have faded, leaving a few brightly, and sometimes wrongly, predominant. The images I made in those moments are of a place extravagant in its beauty, reckless in its fecundity, terrible in its indifference and dark with blood-soaked memories.

Those memories have become my 'one story'. It's about the great broken heart of our culture and the terrible crime of slavery that pierced that heart, exploring the South through what are to me its defining preoccupations: family, death, memory, the land and, overarching all of these, race.

Deep South, Untitled (Fontainebleau), 1998

Blackwater 9, 2008–12

As I worked in the Great Dismal Swamp, the fires there seemed to epitomise the great fire of racial strife in America – the Civil War, emancipation, the Jim Crow era, the civil

and voting rights movements with which my family was involved, the protests and sit-ins of the late 1960s during which my brother was arrested 17 times and, most recently, the Black Lives Matter marches in the summer of 2020.

Something about the deeply flawed American character seems to embrace the apocalyptic as a solution, *The Fire Next Time*, fire as curative. Perhaps we do need to tear it down before we can rebuild. Perhaps fire, uniquely, does cleanse and restore, yielding the small green sprigs and vines starting now to revitalise the Great Dismal Swamp, offering hope for restoration.

But fire does not destroy memories. No matter how our laws are revised to be more equitable, or how our tortured racial past might somehow be mitigated or how completely the Great Dismal Swamp is engulfed in flames, no one will forget. These pictures are a testament and a reminder. ∎

All images are © Sally Mann. Courtesy Gagosian. Text and images from Sally Mann's Prix Pictet Laureate's address, Les Rencontres d'Arles, July 2022

SALLY MANN
Sally Mann, born in Lexington, United States, in 1951, is one of America's foremost photographers and winner of the Prix Pictet *Fire* in 2021. She was named America's Best Photographer by *Time* in 2001. The National Gallery of Art, Washington, D.C., presented her exhibition *Sally Mann: A Thousand Crossings* in 2018, which also appeared as one of her many books. A documentary about her work, *Blood Ties*, was nominated for an Academy Award in 1994.

Women photographers in the Prix Pictet

JAN DALLEY

'A testament and a reminder'. These were words Sally Mann used to describe her *Blackwater* series of photographs, winners of the ninth cycle of the Prix Pictet, *Fire*.

Hauntingly stark and striking images taken in the Great Dismal Swamp, a site of gruesome events in the era of slavery, these pictures go far beyond their immediate subject matter – the blackened and twisted remains of trees and land in the aftermath of the huge fires that devastated the region. Mann creates a deep visual metaphor of the 'tortured racial past' of her country, and evokes the idea of fire as a curative, a devastation holding hopes of cleansing and renewal. The edges of her prints themselves are 'burnt', as if the images too are combustible and transient.

In playing like this with the materiality of her photographs, Mann makes the objects themselves into something else – almost sculptural. The latest of three female winners of the Prix Pictet, she shows how women photographers have often pushed the boundaries of the prize's rubric (its promotion of sustainability) as well as the limits of photography itself. Valérie Belin, winner of the *Disorder* cycle, created startling images with her still lifes – apparently chaotic pile-ups of cheap and cheerful ephemera, gaudy plastic jewellery, fake flowers, broken mannequin heads. The detritus of consumption; the disorder of modern life, its broken dreams.

And then there was Joana Choumali, a photographer from Côte d'Ivoire, who arguably pushed the genre further than anyone. Her intimate images of African life in the aftermath of a terrorist attack are overstitched and embroidered, layered with fabric scraps, to make her powerful points not just about African identity and resilience, but specifically about femaleness and the tradition of women's crafts.

Entitled *Ça va aller*, a French expression loosely translated as 'everything's going to be alright', Choumali's pictures were worthy winners for the cycle's theme of *Hope*. They first appear essentially joyful, full of scampering

LISA OPPENHEIM
Calendar, 1819–1874, 2013. Courtesy of the artist and The Approach

children in bright clothes, peaceful towns and beachside scenes, to which her embroidered embellishments add a dreamlike air, a touch of the surreal. Choumali describes the process of stitching as a catharsis to the collective trauma that she witnessed in Abidjan, evoking the transcending brilliance of thought and imagination as a form of healing.

> Without wishing to break the confidentiality of the jury room, I can say that the debate divided loosely along gender lines among the judging panel

This work takes the materiality of the image to another level as well: with the embroidery, a once reproducible object becomes a unique work. The 'easiness' of photography in our mobile phone age is contradicted by her tangible reminders of labour, of slow craft, of skill and difficulty; embroidery can't be rushed, can't be digitised, can't be reproduced.

Yet, these sprightly, playful, but deeply thought-out images were almost a step too far for the judges. Did this degree of alteration of images, with their explosions of superimposed delicate stitching, change the pieces into something other than photography? Was she questioning, undermining the nature of the genre itself? And weren't they ... well, a bit soft, a bit woman-y? Without wishing to break the confidentiality of the jury room, I can say that the debate divided loosely along gender lines among the judging panel.

The achievements of these winners shine even more brightly when we think about the quality of the shortlists. To focus only on the women in the running: Belin's whacky still lifes were judged against – for instance – Alixandra Fazzina's moving and classically hard-hitting images of refugees escaping Somalia and Sophie Ristelhueber's *Eleven Blowups*, images of craters and explosion sites both real and imaginary.

And pity the judging panel that had to decide, on the theme of *Space*, between its excellent winner Richard Mosse and Mandy Barker's astonishing *Beyond Drifting: Imperfectly Known Animals*. Her floating globules, luminous against black space, are part sci-fi, part 19th-century microbe specimen, but entirely beautiful. Inside each spherical bubble-like shape are what seem to be embryonic life forms, or ghostly creatures from the deep of this or another planet. In fact, they are pieces of plastic debris recovered from the sea. It is superb conceptual work married to the beauty of the image.

> Photography should, therefore, be the most egalitarian of all art forms – the one in which we no longer even have to think about gender

On the same shortlist – and as complete contrasts – Saskia Groneberg's *Büropflanze* ('office plant') brought us a witty take on office life that questions the small anarchies within our quotidian routines, and Beate Gütschow's *S Series*, its apparently bleak cityscapes as stark and ungiving as their title. But gradually we see that, in her digitised collage process, these strictly proportioned 'buildings', devoid of any life, are in fact a form of fantasy landscape.

There have been many more female talents in the Prix Pictet lists: Lisa Oppenheim's mysterious, camera-less process that produces flowers of smoke; Rineke Dijkstra's *Almerisa* series, portraits of a young Bosnian refugee girl over time as she grows from a small child to a young mother, adjusting to the culture of her host country; Laurie Simmons's challenging study of a love doll she ordered ▸

LAURIE SIMMONS
The Love Doll / Day 26 (Shoes), 2010
Courtesy of the artist and Salon 94

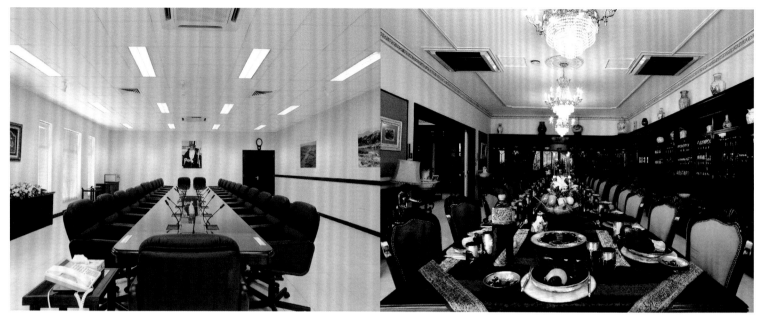

JACQUELINE HASSINK
Her Excellency Lujaina Mohsin Darwish, Joint Deputy Managing Director,
Mohsin Haider Darwish LLC , 13 April 2006

from a catalogue, then photographed in ways to bring this commodified simulacrum of a human woman to characterful life – a disturbing meditation on adult fantasy and desire; An-My Lê's detailed black-and-white pictures of desert military manoeuvres intended to reflect, she says, the more formalised war photography of the 19th century rather than today's rapid and immediate image-grabbing; Jacqueline Hassink's photographs of the boardroom tables and domestic dining tables of a group of successful Arab businesswomen for the theme of *Power*; Rena Effendi's paradoxically gorgeous still lifes and nature scenes from Chernobyl, provoking thoughts on the destructiveness of human beings and their capacity for survival; and Taryn Simons's brilliant *An American Index of the Hidden and Unfamiliar*, sometimes eerie, sometimes disarmingly everyday views of American culture that carry a sense of suspended animation, almost of dread.

From military exercises to a love doll, technical innovation to historical process, work that is conceptual or forensically detailed, strictly minimalist or gorgeously lavish. In all this abundance and range, can we possibly identify such a thing as women's photography, or a female sensibility in the genre? Almost certainly not.

The art of photography and women as professional artists were born at almost the same time and have grown up together. Anna Atkins published her cyanotypes of algae in 1843, just one year after the process had been invented. It is said to be the first photography book ever. Since then, women have scored numerous firsts and proved themselves again and again to be as adept,

as bold and as visionary at the art and craft of photography as their male colleagues – often against the odds, and against all the well-known obstacles and prejudices.

Photography should, therefore, be the most egalitarian of all art forms – the one in which we no longer even have to think about gender. Yet still, somehow, we do. Still, somehow, there seem to be barriers. Three out of nine Prix Pictet winners have been female. Is that enough? Is it even significant? Or might we just as well be wondering how many of them had brown eyes or liked anchovies?

That debate will go on. In its first decade, the Prix Pictet has undoubtedly done much to further the careers of many fine female photographers. In turn – and perhaps even more markedly – the women photographers have given a huge amount to the prize and its fine reputation. They've shown work that displays it all – not just brilliant technical skills, innovation, imagination, but all the joy and pathos, the power and delicacy, the wit and provocation, the frivolous fun and the deep thinking that are the glories of photography. ∎

JAN DALLEY
Jan Dalley is the *Financial Times* Arts Editor. She is responsible for the *FT*'s coverage of all the art forms, including *Life & Arts*. She also writes features, interviews and occasional columns. Dalley has been a regular jury member for the Prix Pictet for *Earth*, *Power*, *Space* and *Hope*.

Photographs

▲▶
VALÉRIE BELIN
Left: *Portrait of Gaby*, 2020
Right: *All Star*, 2016
A psychological exploration of a
fictitious woman and an exploration
of media and consumption in an
age of hyper-abundance

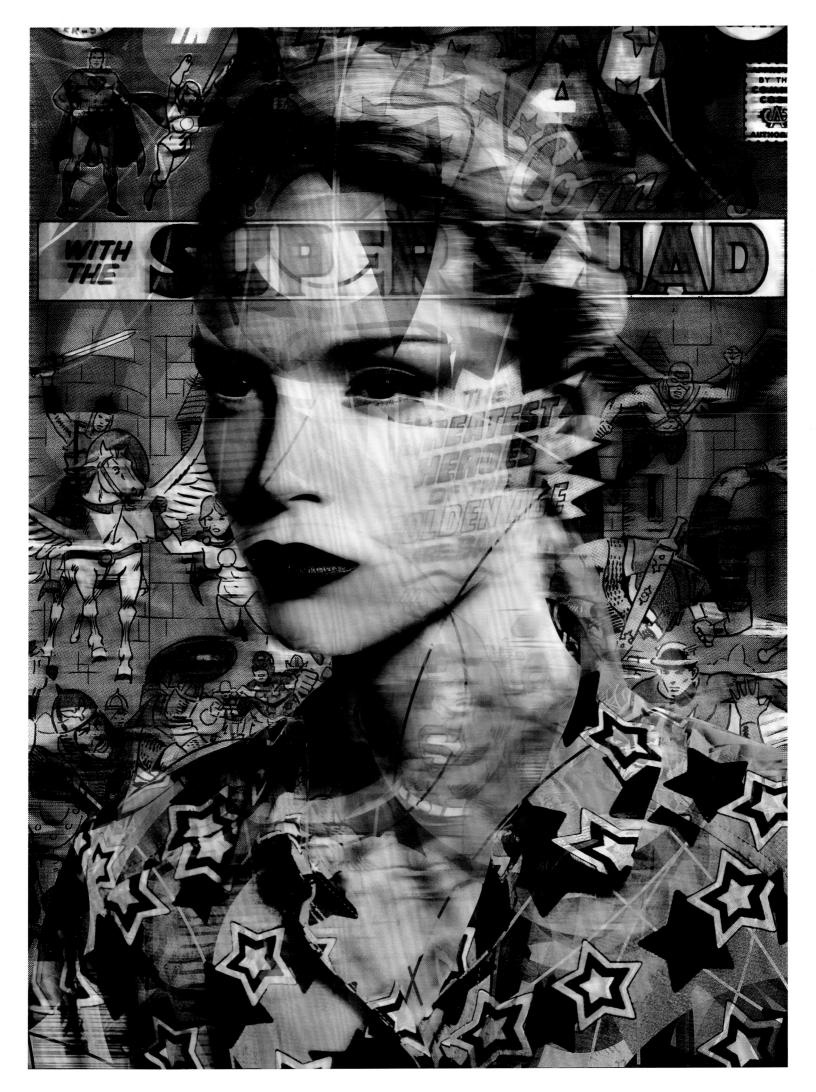

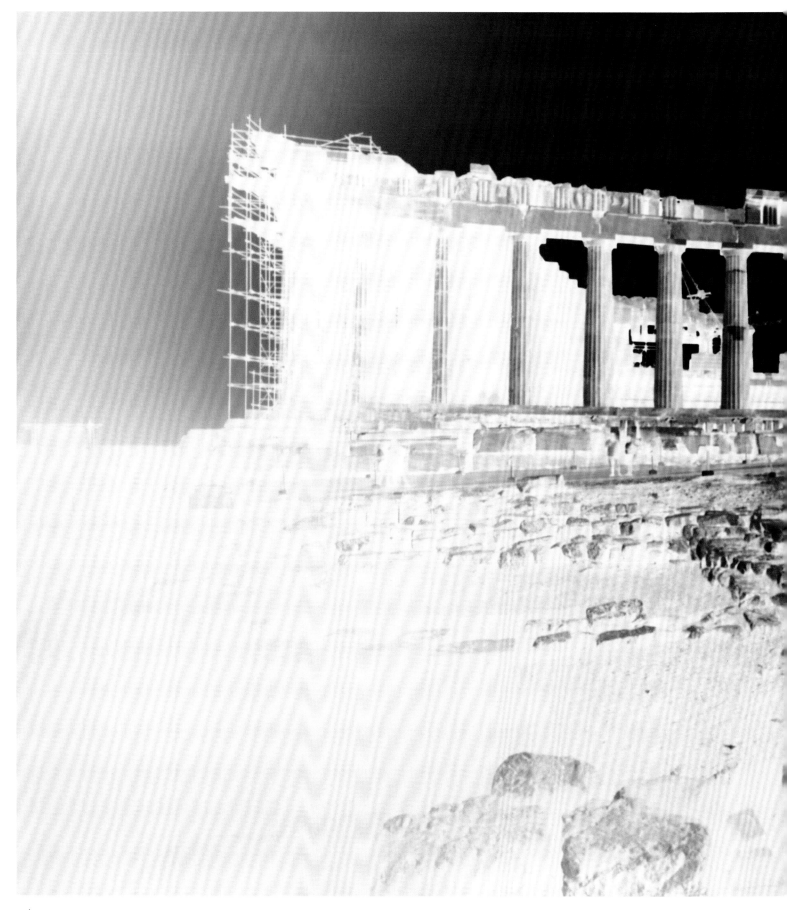

VERA LUTTER
Temple of Athena, Acropolis, 2021
The grandeur and dignity of the
Parthenon Temple in dawn's silence

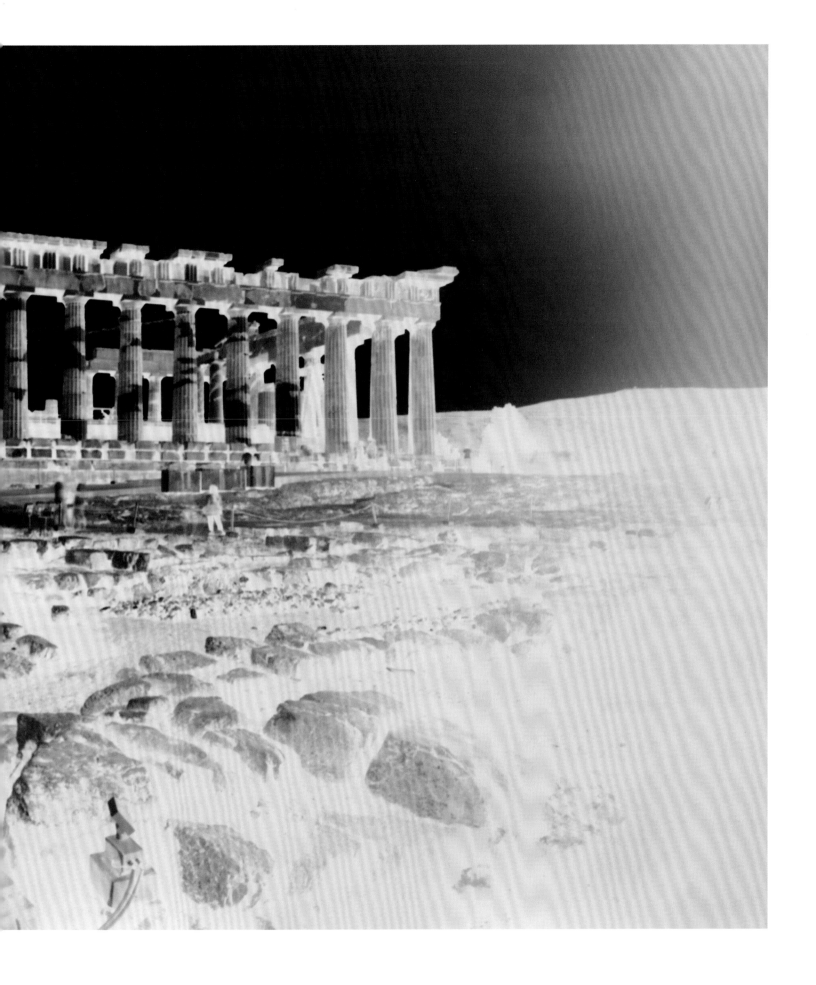

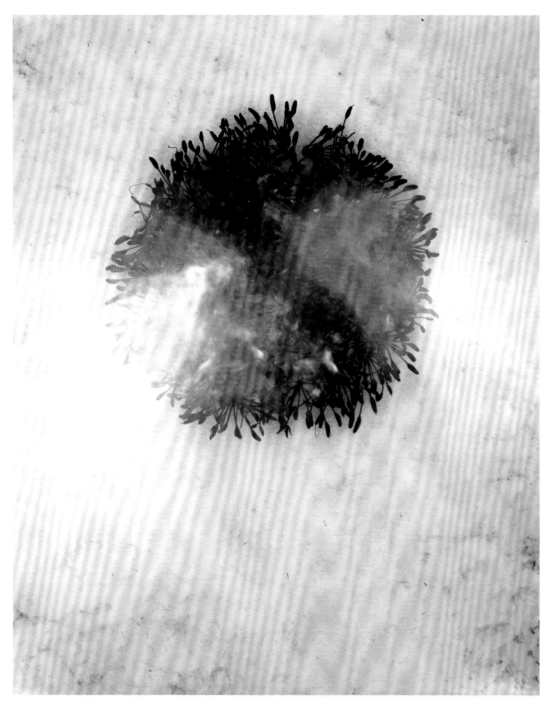

▲►
YAN WANG PRESTON
Winter – Seed Capsules, 2021
I collected seed capsules before
arranging them on a bed of snow

▼
AWOISKA VAN DER MOLEN
'566-16', 2020
The human body possesses a deep
internal memory, an unconscious
instinct that recognises when we get
closer to nature

▲

SASKIA GRONEBERG
Vesuv, Venus, 2022
Searching for the age-old dream of a
paradise on Earth, the harmonious
coexistence of humankind and nature

My metaphorical
approach questions the
varied conditions for
making a family today

FLORIANE DE LASSÉE

MARGARITA MAVROMICHALIS
Mother's Day, 2021
Turning the camera on myself was my
way of slowing down and exploring what
was happening around and inside me

▲
JACKIE NICKERSON
Hybrid, 2022
The individual, variously
disassembled and reconstructed,
struggles to exercise agency

JULIA FULLERTON-BATTEN
Flexible Roxy, 2021
A serpentine dance of the
human body

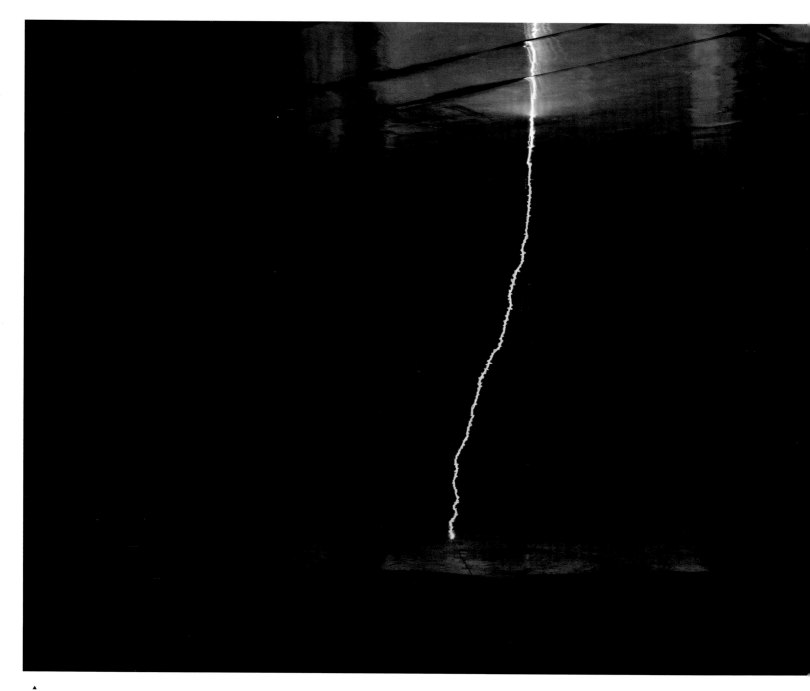

MARINA GADONNEIX
Untitled (Lightning), 2020
The elusive in relation to the intrinsic
human need to measure and control
what surrounds us

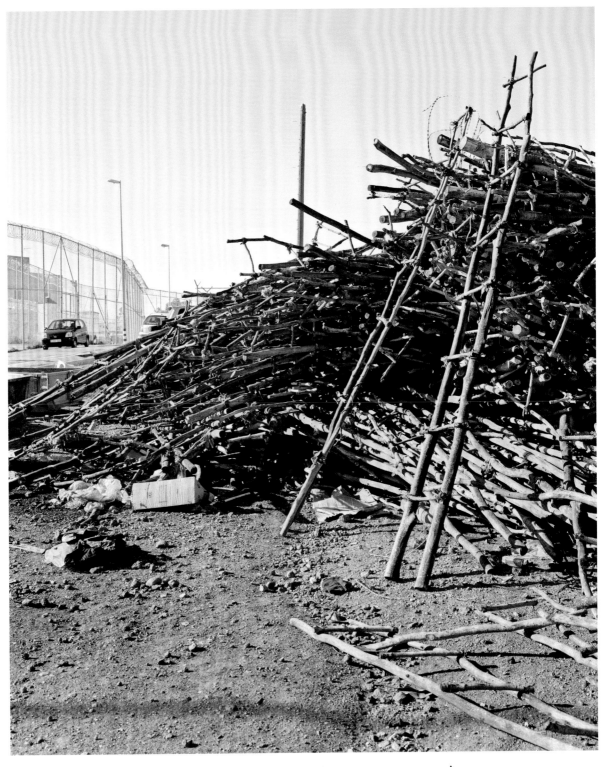

EVA LEITOLF
Ladders, Melilla, 2006
My photographs avoid the shock effect
of portraying violence and acquire
significance through avoiding pathos
and instrumentalisation

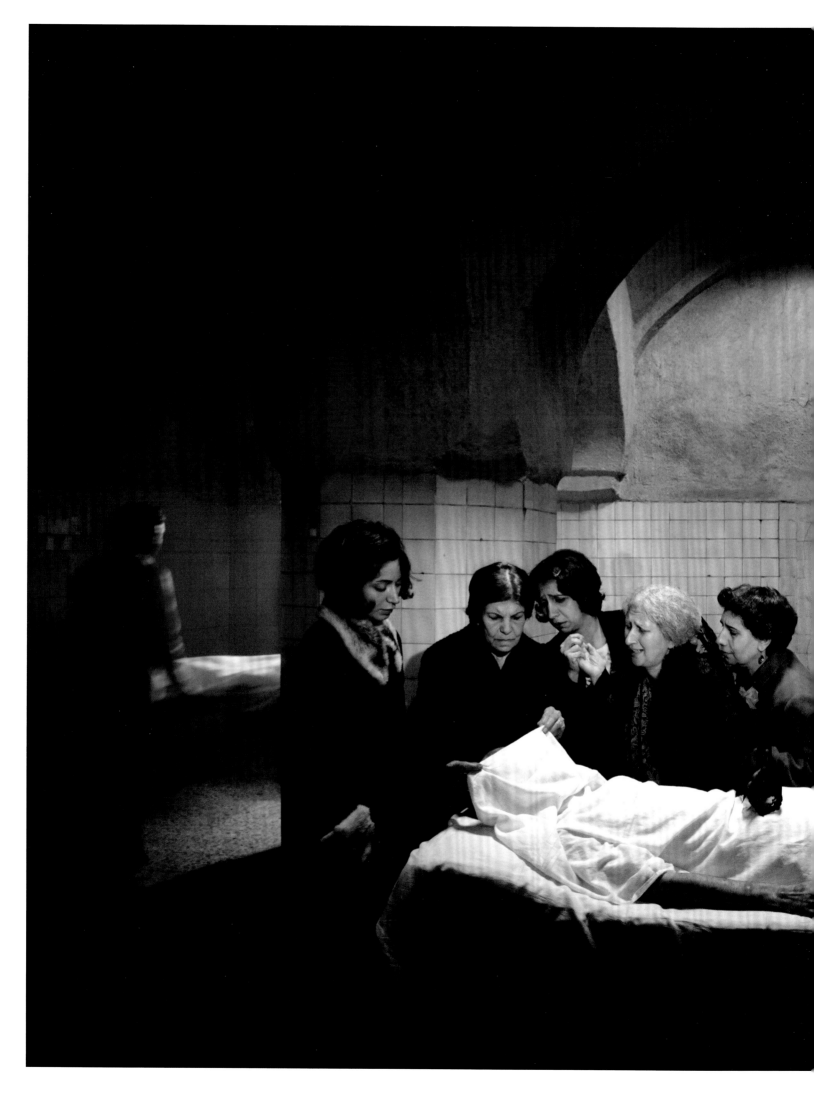

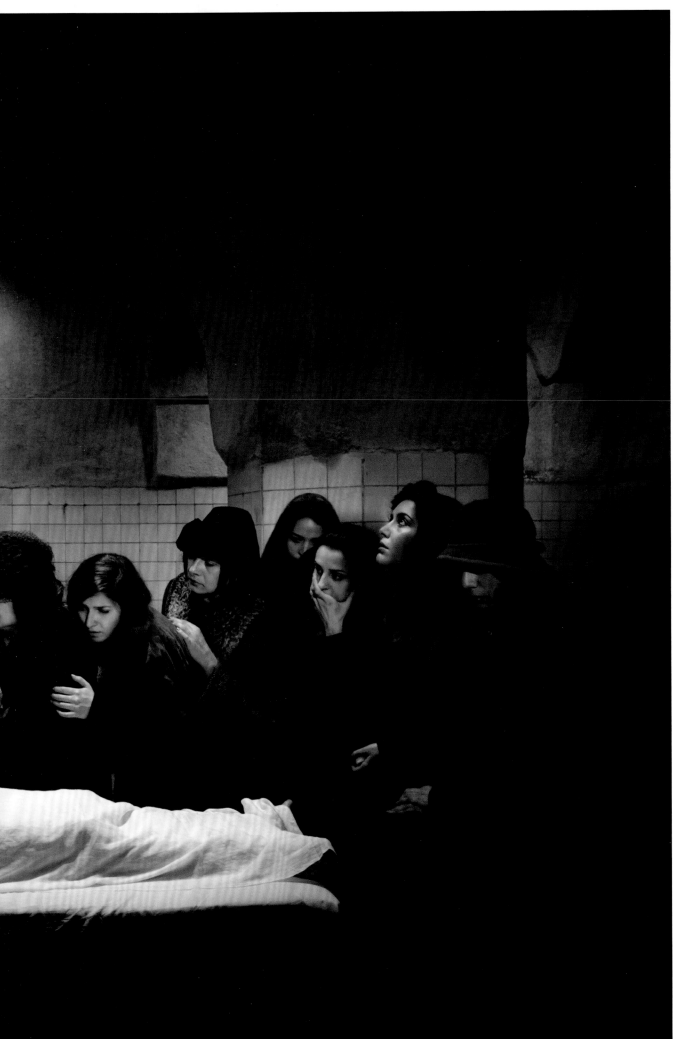

AZADEH AKHLAGHI
Taghi Arani, 2012
Can we come upon a
radical crack in history
and walk with the spirits
of the past along our
contemporary streets?

RITA LEISTNER
Left: *Valerie Buhagiar and Brandon Oakes*, 2020
Right: *John Borra*, 2020
A subculture of professionals who can plant
an astonishing 2,000–5,000 trees in a day

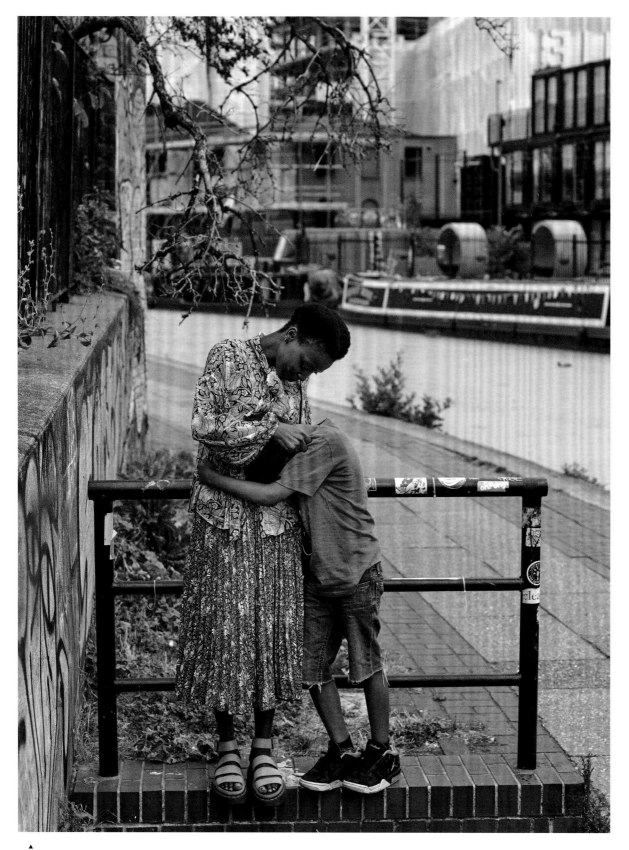

POLLY BRADEN
Barbeline with Elijah, 2021
Single parents have been hardest hit by
austerity, and these collaborative photographs
capture the families' sense of adventure,
optimism, creativity and ambition

MANDY BARKER
CROWN 2.5L – Entangled Rope with Coral,
Henderson Island, 2019
The images have passed through the
cavity of a chicken feeder, so are not
intended to be perfect, but to reflect
an imperfect world

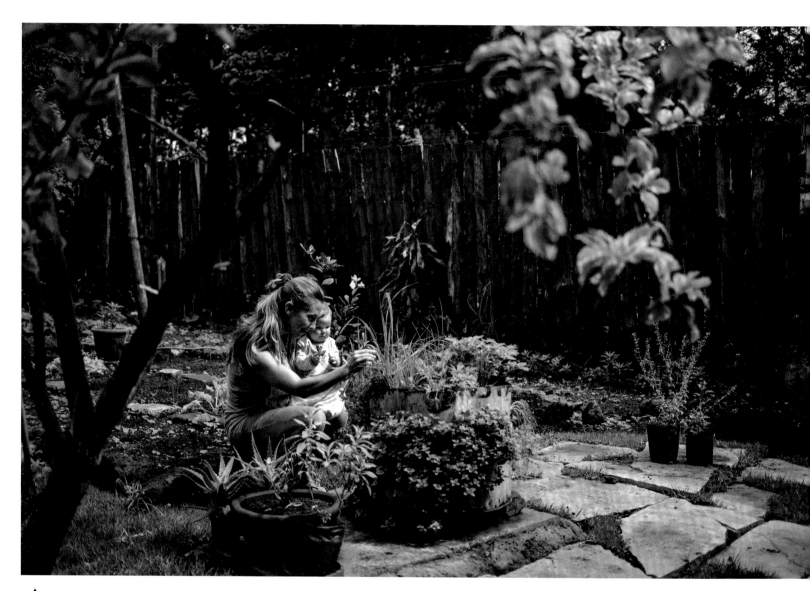

GEORGINA GOODWIN
A Delicate Balance –
Motherhood in Lockdown, 2020
A new baby and a bubble
of uninterrupted time

▲
RINKO KAWAUCHI
M/E, 2019
I sensed myself and Earth mirroring
each other, as if we had become one

▼

CHLOE DEWE MATHEWS
In Search of Frankenstein, 2022
I attempt to offer a fresh
perspective on contemporary
issues around landscape and
the environment

ALIXANDRA FAZZINA
Hargeisa, Somaliland Region of Somalia, 2018

A parable for our times, untangling powerful metanarratives that cloak the links between human smuggling and protracted conflict

ALIXANDRA FAZZINA

▲
DIANA MARKOSIAN
Santa Barbara, 2020
I have reenacted memories
from my childhood as a way
of processing my past

CRISTINA DE MIDDEL
Una Piedra en el Camino, 2021
A heroic and daring journey

I have come to
understand that
what I was hoping to
find in my journeys
abroad, I finally
discovered in my
own home

JOANA CHOUMALI

JOANA CHOUMALI
Here I Stand, 2022

▲
LÉONIE HAMPTON
A Language of Seeds, 2020
Gardening is reciprocity in action

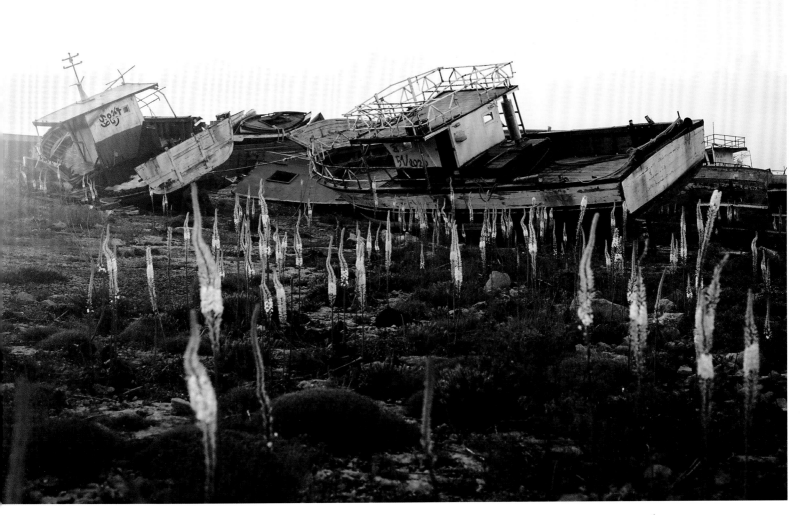

▲
JILLIAN EDELSTEIN
Boat Graveyard, 2020
Human spillage in the environment.
It is untenable, unsustainable on
so many levels

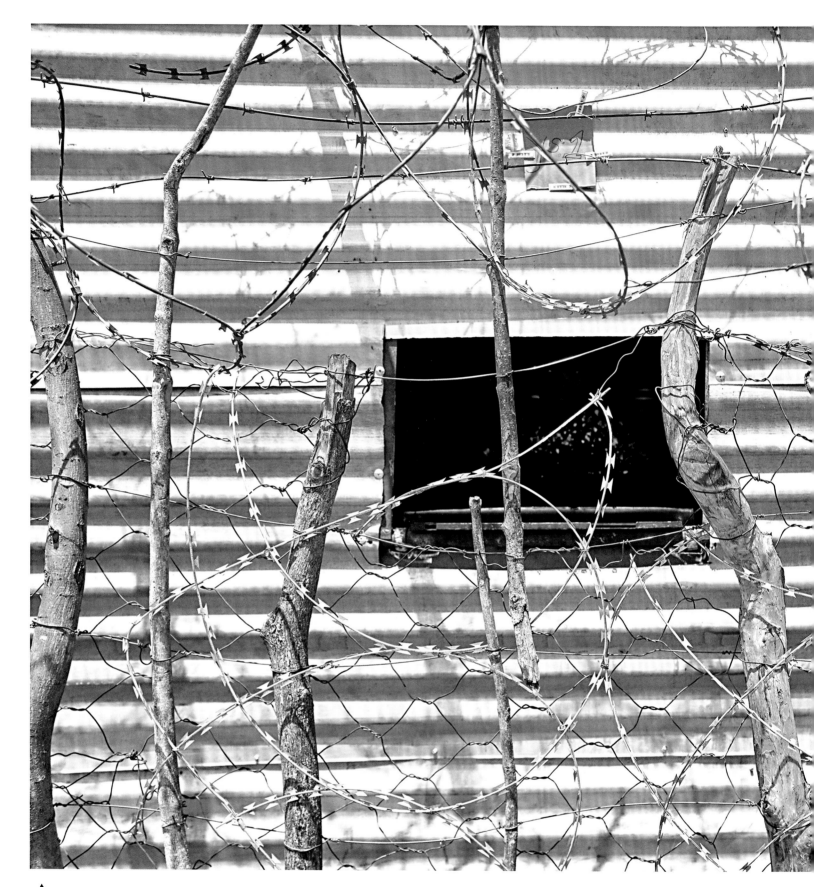

MARGARET COURTNEY-CLARKE
Caged Grass, 2019

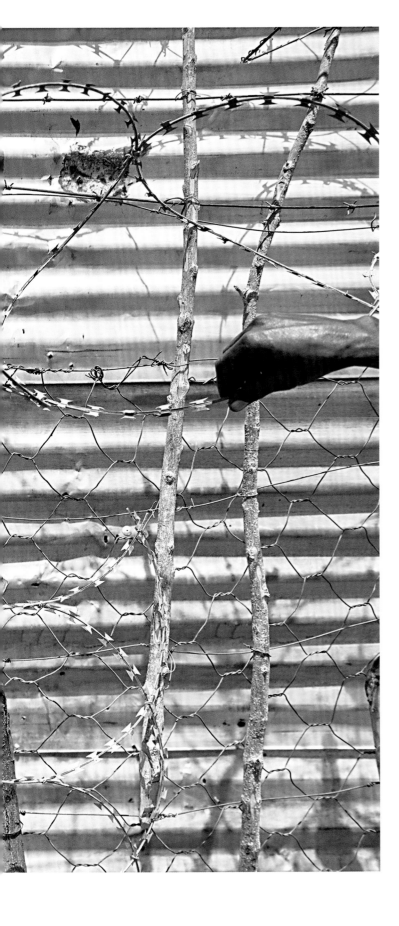

The geometry of the
rectangle entraps
humans, animals
and plants in its
defining limits

MARGARET COURTNEY-CLARKE

▼

TARYN SIMON
Broken promises – declarations that
have been violated and withered

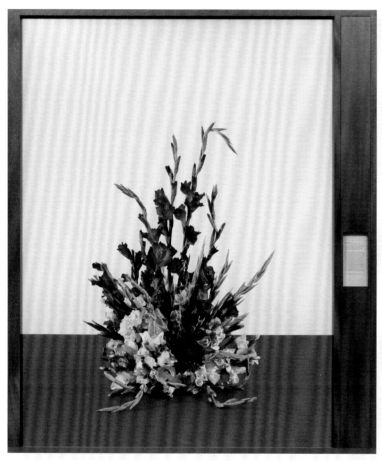

TARYN SIMON *Gdańsk Agreement. Gdańsk Shipyards, Gdańsk, Poland, August 31, 1980,*
Paperwork and the Will of Capital, 2015

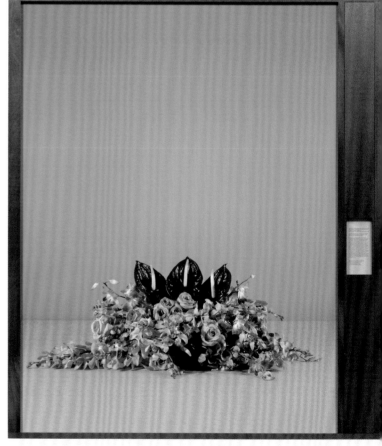

TARYN SIMON *Memorandum of Understanding between the Royal Government of Cambodia and*
the Government of Australia Relating to the Settlement of Refugees in Cambodia.
Ministry of Interior, Phnom Penh, Cambodia, September 26, 2014, Paperwork and the Will of Capital, 201

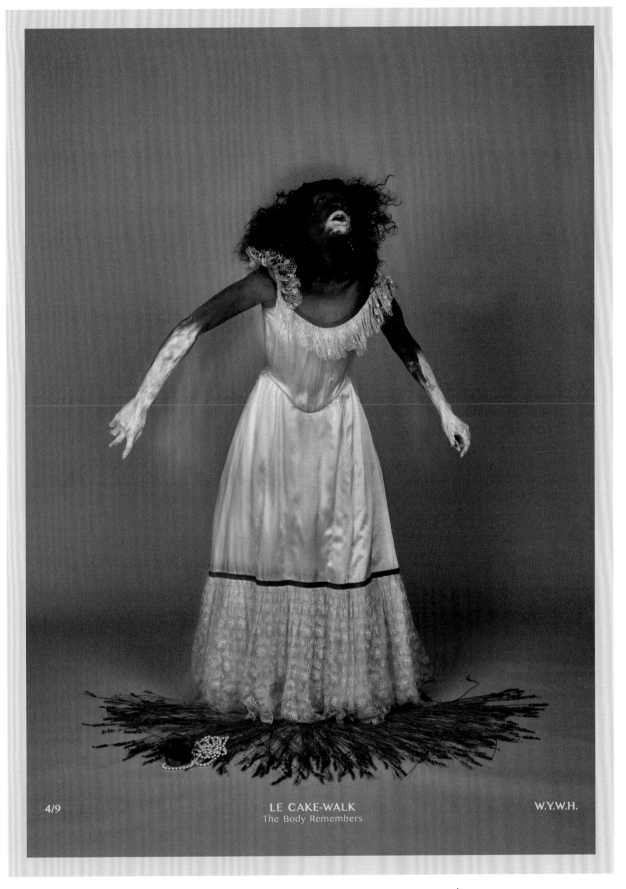

LE CAKE-WALK
The Body Remembers

4/9

W.Y.W.H.

▲
HEATHER AGYEPONG
Le Cake-Walk: The Body Remembers, 2022
The series uses satirical commentary
and depictions of radical self-worth to
disrupt the roadblocks affecting our
collective mental health

DORNITH DOHERTY
Vault Interior, Svalbard Global Seed Vault,
Spitsbergen Island, Norway, 2010
The gravity of climate change and
political instability has created the
need for this remote 'Doomsday Vault'

UTA KÖGELSBERGER
Cull, 2021
The project cuts across political
divides deeply entangled with
wildfire and forest management

TOMOKO KIKUCHI
Liangzi at the Funeral, 2022
The summoning-up of transgender people's role as connectors, crossing the boundaries of sexual dichotomy and thus of life and death

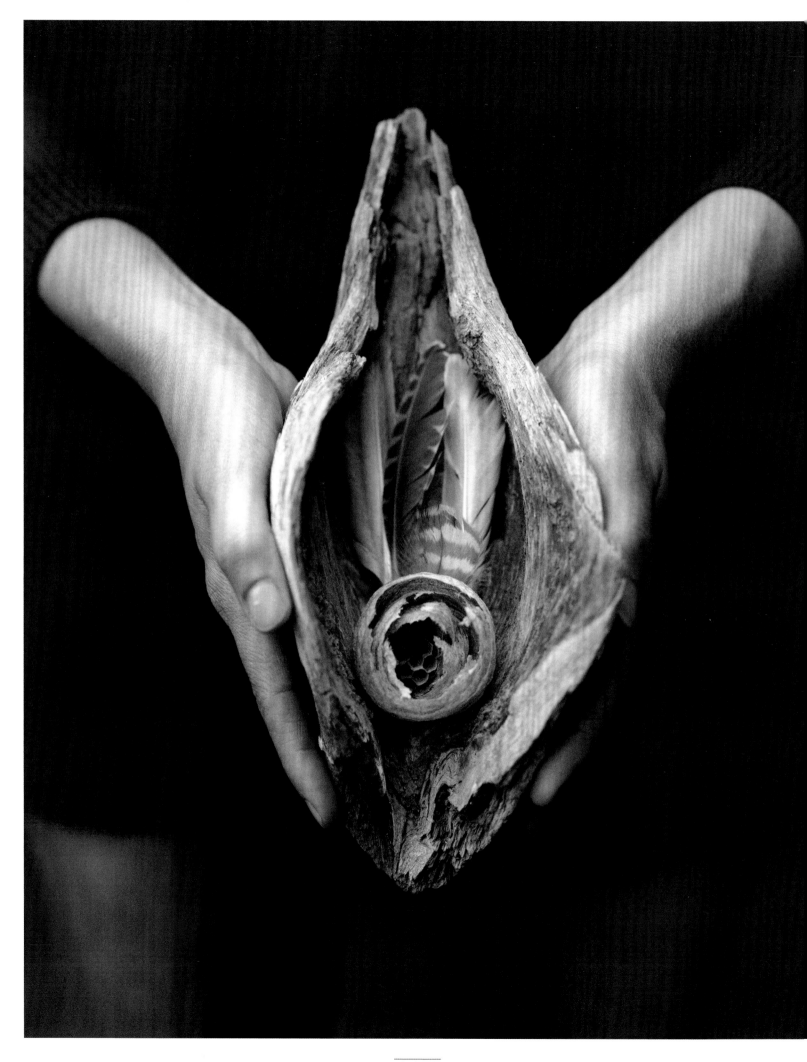

Experiences of a shared
past in an unfolding present

AN-MY LÊ

AN-MY LÊ
Film Set (Free State of Jones),
*Battle of Corinth, Bush,
Louisiana*, 2015

▼
TOMOKO SAWADA
Bloom, 2017
If someone saw my work and bloomed,
I would be glad

▲
LARA ATALLAH
Untitled, Beirut #11, 2017
The photographs, devoid of humans,
depict the sea as a sombre place

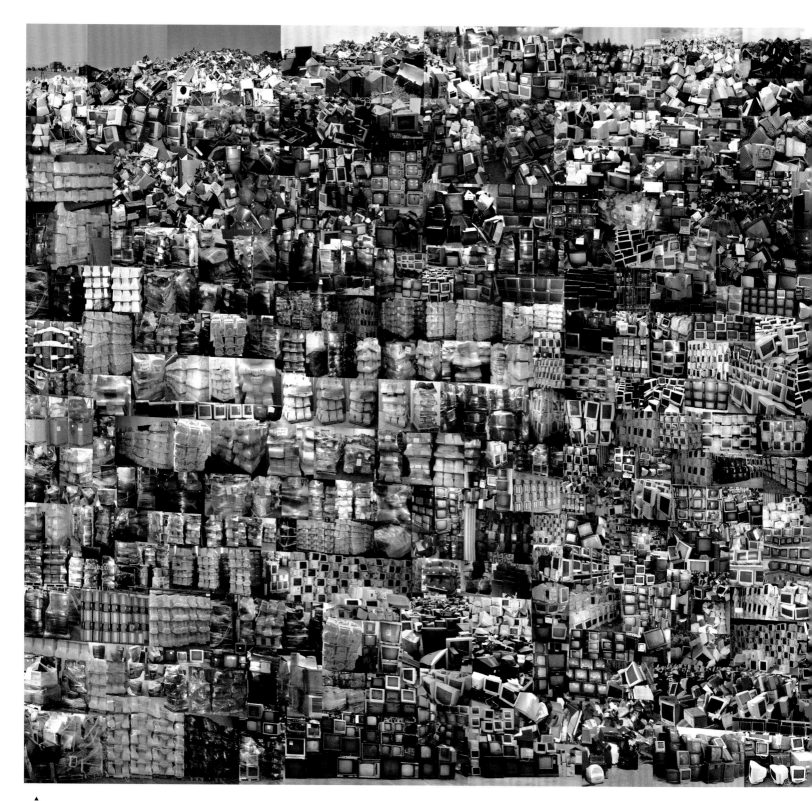

PENELOPE UMBRICO
1320 TVs from Craigslist, 2009–20
I collect images of technology for sale
on eBay and Alibaba and aggregate
them to create virtual landfill

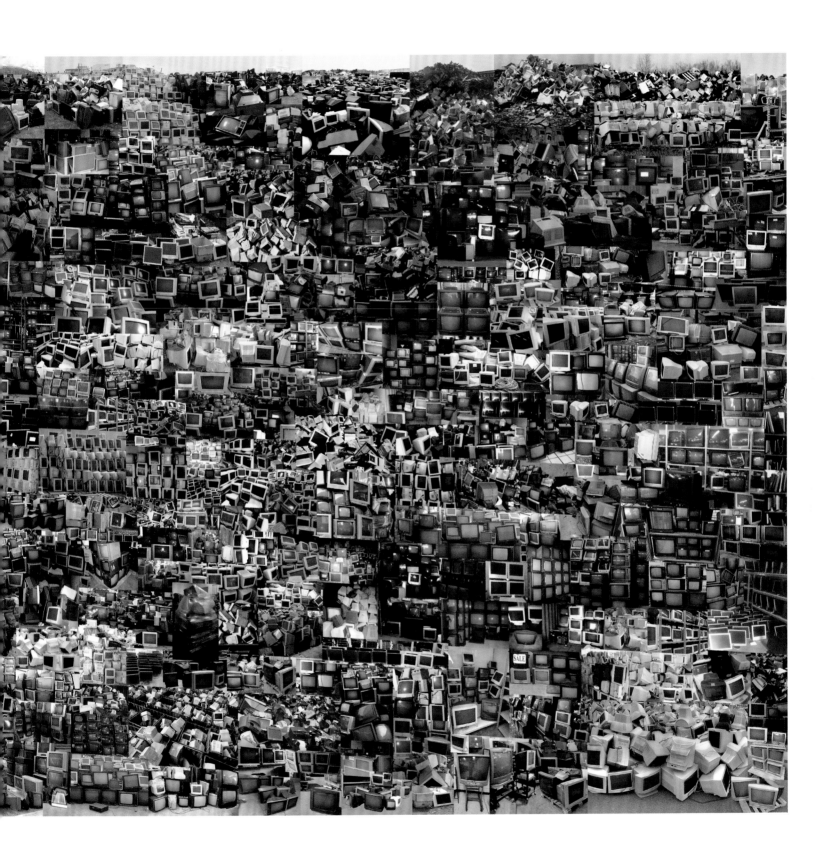

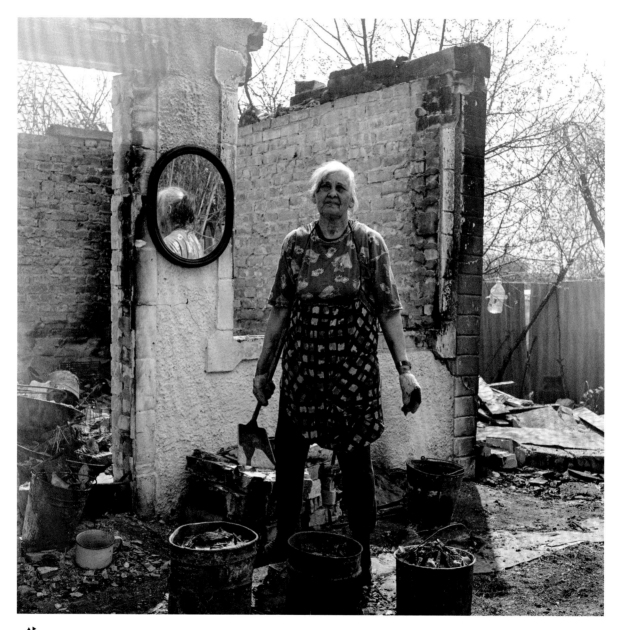

▲▶
RENA EFFENDI
Left: *Irina Kovalenko's Home reduced to a Pile of Rubble, Zalissia, Ukraine,* 2022
Right: *Zalissia Village, Ukraine,* 2022
They persevered, sweeping the rooms and tending to their small plots

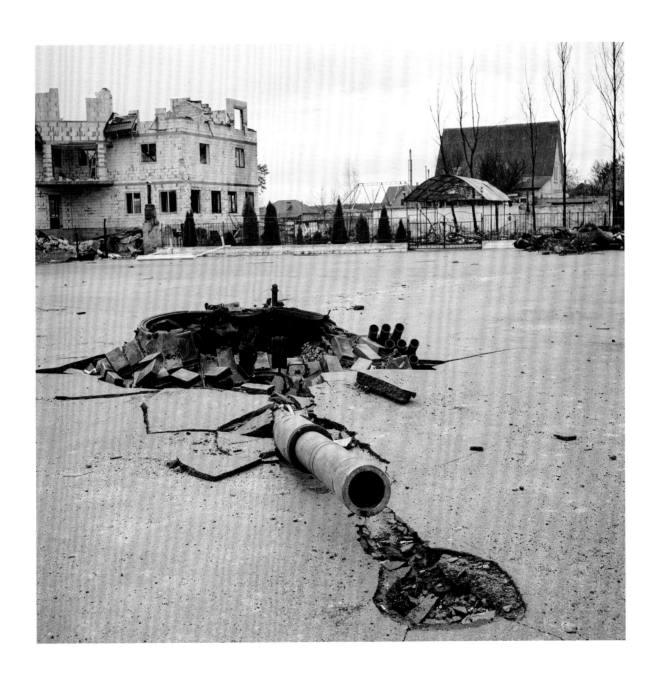

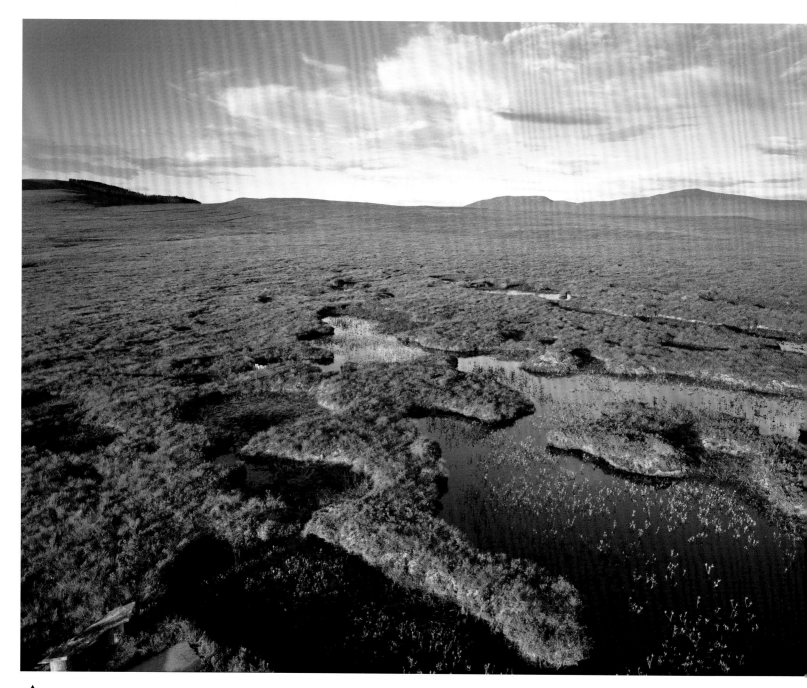

▲
SOPHIE GERRARD
The Flows, 2022
These almost magical places
are being reinvigorated through
careful conservation

GOHAR DASHTI
Home, 2017
Nature is what connects me to the multiple
meanings of 'home' and 'displacement'

▲
ZEYNEP KAYAN
Rope I, 2022
I experiment on variations of an image,
a movement, a gesture, a sound or a
line of words

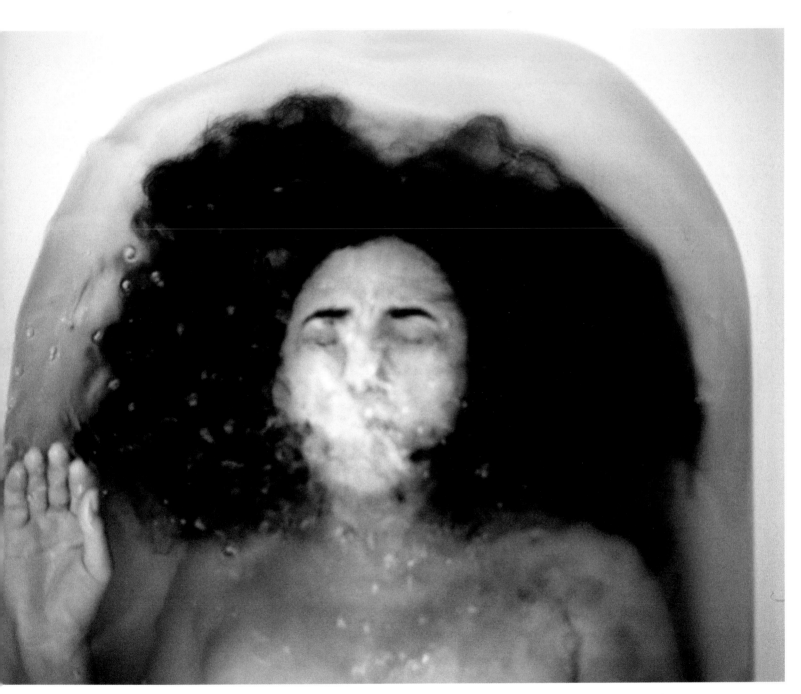

MYRIAM ABDELAZIZ
The Tunnel, 2019
A lonely and painful place where
confusion and doubt have taken
over your mind

The potential
of metaphor
for articulating
our changing
relationships with
the natural world

SUSAN DERGES

▲
SUSAN DERGES
Tidepool 39, 2015

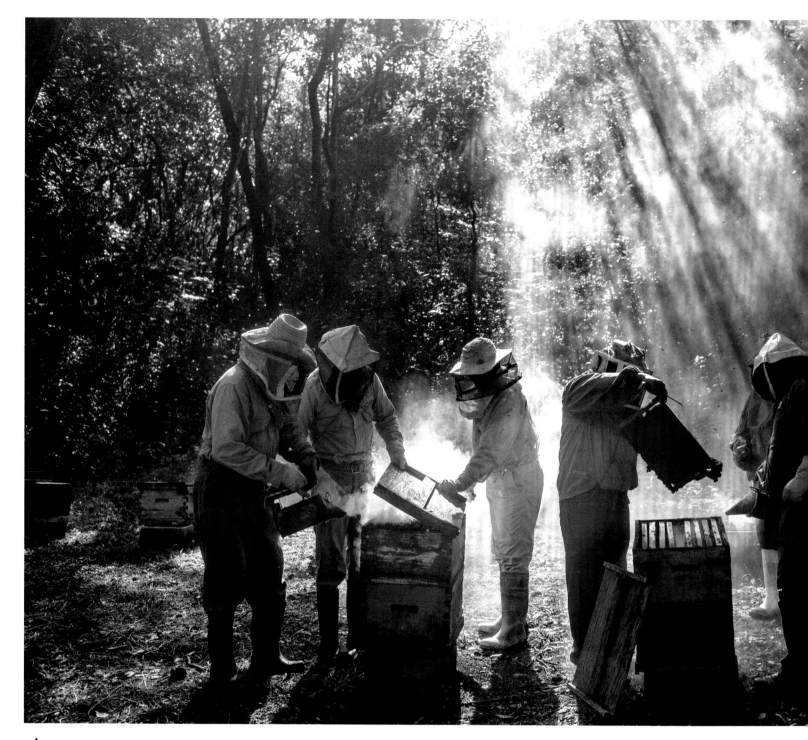

NADIA SHIRA COHEN
Mayan Beekeepers, Tinun, Mexico, 2018
In the past few years, hives have
been disappearing and the honey
has been contaminated by pesticides

LIZA AMBROSSIO
Vuelta al Vientre, 2018
My series is an act of entropy
and exhaustion

▲▶
VANESSA WINSHIP
Yarlside Academy Class 5, January 2020
I remain concerned with young people,
their education and their ability
to be properly nourished, physically
and intellectually

JEONGMEE YOON
The Blue Project: Kyungjin and his Blue Things, Gyeonggi-do, South Korea, 2017
The power of pervasive
commercial advertisements

Nature, given a chance, comes back to life

CLAUDIA JAGUARIBE

CLAUDIA JAGUARIBE
Asphalt Flower, 2022

▲
ALEX PRAGER
Afternoon, 2021
The feeling that something was on
the verge of breaking and from there
everything else would collapse

MITRA TABRIZIAN
The Silence of Numbers, 2022

The conventional view
that everything is going
to be all right is upended
and the precariousness of
our existence is revealed.
Yet, we ignore the urgency

MITRA TABRIZIAN

PAOLA DE PIETRI
Untitled, 2017
The houses seem relegated
to the sphere of archaeology

The interference of my
brushstrokes became
a mirror of human
intervention in nature

ALETHEIA CASEY

NICI CUMPSTON
Oh my Murray Darling, 2019
We rely on them to sustain us physically,
emotionally and spiritually – and, in turn,
it is our responsibility to care for them

A lifelong spiritual connection to the natural kingdom guided me

JANELLE LYNCH

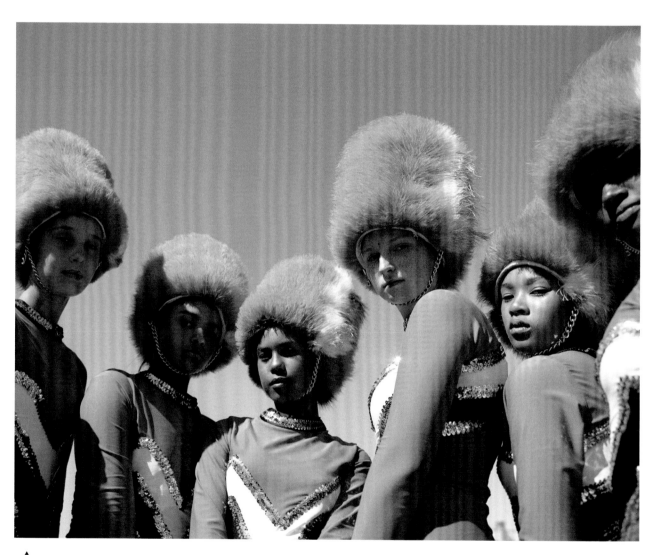

ALICE MANN
Drummies, 2019
Being a drummie offers girls a
sense of belonging and self-worth

▲
SOLANGE ADUM ABDALA
The Conversion of the Trace #1, 2019
The photographic process becomes
an analogy for climate change

RUT BLEES LUXEMBURG
Latent Babylon, 2019
The image is disrupted by the marks
of time – dust and spillages and the
glare of urban light

▼
ERIKA KOBAYASHI
*Seance – a Daughter's Daughter
and a Father,* 2021
She waited for the sacred
Olympic fire

Artist Statements & Biographies

Artist Statements & Biographies

SONJA BRAAS

The Other Day appears to invite a sentimental, comfortably melancholic and nostalgic gaze on nature. We mourn the loss of our romantic ideals of landscape, yet we are the primary cause of planetary damage. Nature devoid of human impact has vanished – and with it the promise of escapism from our lives, from ourselves. Wherever we go, we are already there.

Signs of manufacturing are conspicuous in the images of this series, disallowing nostalgia: the edge of a table holding a desert, or a newspaper print suggesting the lines of fields. Yet, the images, using sets I build myself, are not dystopian, but gentle, beautiful. The disturbance arises from the thorn of dealing with the discovery of human interference, from being asked not to look away.

Sonja Braas, originally from Germany, is based in New York and has worked in South America, Africa and Australia. She has exhibited across Europe and the United States, including at the Philadelphia Museum of Art. Her books include So Far, *published in 2013. She won the Reinhart Wolf Prize in 1997.*

© VG Bild-Kunst, Bonn 2022
Courtesy of Galerie Tanit, Munich

VALÉRIE BELIN

All Star is both a portrait and a still life – a psychological exploration of a fictitious woman and an exploration of media and consumption in an age of hyper-abundance. The characters in this series, who seem to live in a closed world, find light only through the fictive glow of comics: the spark of a gaze, reflections, the glint of a dagger, white smoke from explosives.

Parisian photographer Valérie Belin was born in 1964 and gained a diploma of advanced studies in the philosophy of art from Panthéon-Sorbonne University, Paris, in 1989. She won the Prix Pictet in 2015 on the theme of Disorder. *Her work has been exhibited worldwide and is in numerous public and private collections. She is a member of France's Ordre des Arts et des Lettres.*

VERA LUTTER

It was a unique experience to photograph the Acropolis for *The New York Times*. My pinhole box-cameras can only be outfitted with a single sheet of photographic paper, which, if all goes as planned, yields one unique, negative image. My effort is great, the images few. I arrived before sunrise, with the tender warmth of the prior day still radiating from the old stones. The grandeur and dignity of the Parthenon Temple in dawn's silence was unforgettable.

The absence of the Greek Marbles creates a profound void, a wound carved into the heart of antiquity. I felt deprived of seeing all that has survived to this day in its entirety, in the place where it was created.

Vera Lutter studied sculpture in Munich, Germany, before moving to New York, where she lives and works. She received the Pollock-Krasner Foundation Grant in 2002 and a Guggenheim Fellowship in 2001. Lutter was shortlisted for the Prix Pictet Growth *in 2010, and in 2017 became Los Angeles County Museum of Art's first artist in residence.*

© VG Bild-Kunst, Bonn 2022

YAN WANG PRESTON

Winter – Seed Capsules is from the series *Autumn, Winter, Spring and Summer,* for which I studied and appreciated materials collected from a single *Rhododendron ponticum* shrub. The series is developed to investigate the term 'non-native and invasive species'. Most such species, including *Rhododendron ponticum*, were introduced during the colonial era. Now, they are seen as threats to native British ecology, suggesting contested ideas of ecology and national landscapes.

Are there other ways to understand rhododendrons? I was inspired by modern study methods and traditional Chinese nature philosophy. I collected seed capsules before arranging them on a bed of snow in the Chinese composition of a circle within a square. I then set fire to them. Snowfall half-buried the seeds afterwards, helping complete the piece.

Yan Wang Preston, born in 1976, trained in medicine at Fudan University, Shanghai, China, before moving to England in 2005 and becoming a photographer. She won 1st prize in the landscape category at the Sony World Photography Awards in 2019. Her most recent exhibition was at the Royal Botanic Garden, Edinburgh, in 2022. She has published two monographs.

© VG Bild-Kunst, Bonn 2022

AWOISKA VAN DER MOLEN

My black-and-white, analogue images describe the experience of a primordial space I encounter when immersed in deep, untouched nature. Because of cascading technological revolutions, our society has evolved enormously over the last few centuries. Our bodies, however, have not evolved at the same pace and we suffer when we are cut off from nature. Yet, even as we are engulfed in this modern world, I believe the human body possesses some deep internal memory, an unconscious instinct, that recognises when we get closer to the kind of place from which we stem: the uncorrupted territory of nature. The experience of this return is what I seek to visualise through my images.

Born in 1972, Dutch visual artist Awoiska van der Molen studied in the Netherlands and the United States and is known for her rigorously produced nature photographs. She was shortlisted for the 2019 Prix Pictet Hope *and the 2017 Deutsche Börse Photography Foundation Prize. The most recent of her three books is* The Living Mountain, *published in 2020.*

SASKIA GRONEBERG

Since the Enlightenment, the understanding of nature in the Western world has undergone a profound transformation, and no medium captures this quite like the English landscape garden. In *Vesuv, Venus*, I explore the English-style Wörlitzer Park in central Germany, searching for the age-old dream of a paradise on Earth, the harmonious coexistence of humankind and nature.

Space and time grow indistinguishable, winter follows spring, detail follows sequence, dream leads to deconstruction. A model of Vesuvius, fashioned from enormous blocks of stone, and a replica of the Venus de' Medici deconstruct the antipodes of masculine and feminine, earthly and divine, darkness and light. The plants, buildings, canals and wildlife are a dreamlike scenery in which visitors are both observers and protagonists in a never-ending play.

Saskia Groneberg, born in 1985 in Munich, Germany, meditates on the relationship between man and nature. She has won many awards and was shortlisted for the Prix Pictet Space *in 2017. Her work has been exhibited in the Victoria and Albert Museum, London, in Zurich and Mexico City as well as in Germany.*

p28 FLORIANE DE LASSÉE

The world is being changed by the growth of infertility. In developed countries, it is estimated that at least eight per cent of couples have difficulty conceiving, rising to one in seven in the United Kingdom. The increasing age at which women decide to conceive could explain this, in addition to changes in lifestyle caused by climate, pollution and stress. The demand for solutions is increasing. Sterility is no longer considered inevitable and the limits of what is possible are constantly being pushed back by technology. The challenges then become ethical. Where do we draw the line of what is acceptable?

I bring an artistic and poetic perspective to this phenomenon, questioning without militancy. My metaphorical approach questions the varied conditions for making a family today.

Floriane de Lassée, born in Paris, France, in 1977, studied there and in New York. She has travelled extensively to create series such as Inside Views, *the subject of two monographs, and she has held numerous solo exhibitions both in Paris and internationally, from Chicago to Beijing. Floriane de Lassée is co-artistic director for the Biennale Photoclimat in Paris in 2023.*

p30 MARGARITA MAVROMICHALIS

As Nelson Mandela said, 'the greatest glory in living lies not in never falling, but in rising every time we fall'. The Covid-19 pandemic found the world unprepared and left it numb. Many lives were lost or changed forever. It widened political and social divides, but also gave us the chance to re-evaluate our life choices.

Turning the camera on myself was my way of slowing down and exploring what was happening around and inside me. Through my series of self-portraits titled *As Time Stood Still*, I strove to create images containing tensions between pain and humour, presence and absence, the seen and the unseen, in the hope of building a body of work that will transcend the pandemic period and remain relevant.

Greek-born Margarita Mavromichalis has spent her life living around the world, speaks five languages and is a trained interpreter. She has won numerous awards. Her work has been exhibited worldwide and is held in collections including the Museum of the City of New York.

p31 JACKIE NICKERSON

Field Test reflects a contemporary reality in which the human subject is a compromised, problematic entity. Individuals, enmeshed in systems of power, economics and surveillance, are indentured as hapless consumers and commodified entities. In these photographs – or, one could say, photo-sculptures – the individual, variously disassembled and reconstructed, struggles to exercise agency. This struggle is affected by a destabilising background of global shifts in manufacturing, production and supply chains, disruptive technologies, rampant inequality, mass surveillance and migration, biohazards, misinformation and environmental destruction. Plastics – ubiquitous and useful, but destructive – are to the fore in the images. *Field Test* elaborates my long-term interest in how people experience and impact the world around them and how their circumstances shape their lives.

Jackie Nickerson, born in 1960 in Boston, United States, is based in London and Ireland. She originally trained as a fashion photographer. She then lived on a farm in Zimbabwe for five years in the 1990s, and travelled and researched extensively in Africa. Her most recent book, Field Test, *was published in 2020.*

p32 JULIA FULLERTON-BATTEN

The world is facing serious environmental and social problems and empowered women are crucial for sustainability; at the same time, young girls are facing a crisis of confidence at a critical time in their development. Young women need help to identify the change they want to see in the world and to build their knowledge, skills, resilience, confidence and wellbeing so they can realise that change.

Julia Fullerton-Batten was born in Bremen, Germany, in 1970 and is settled in London. She is known for highly cinematic, visual storytelling. She has won numerous awards and is a frequent international speaker and competition judge. Her work is in collections including the National Portrait Gallery, London, and the Musée de l'Elysée, Lausanne.

p34 MARINA GADONNEIX

I combine documentation, simulation and fiction to make the energy around objects visible. In my photographic series *Phénomènes* ('Phenomena'), I explore scientific models that replicate natural events by probing the theatricality of the laboratory.

Through their artificial production, these phenomena – such as an avalanche, a tornado, lightning – take shape and become tangible entities we can grasp. The enigmatic and seductive atmosphere created by these representations evokes the sensory rather than the rational. There are few clues to help us understand whether what is happening in the image is something marvellous or catastrophic.

In my staged images, I explore the notion of the elusive in relation to the intrinsic human need to measure and control what surrounds us. For example, *Landslide*, *Tornado* and *Wildfire* provide fascinating images of natural disasters whose frequency seems to increase with global warming.

Marina Gadonneix was born in 1977 in Paris, France, where she lives and works. She graduated from the École nationale supérieure de la photographie, Arles, in 2002. Her recent prizes include the Prix Niépce in 2020. Her work has appeared in numerous exhibitions in France and internationally, and she is working on a solo show for the Centre Pompidou, Paris, opening in April 2023.

p35 EVA LEITOLF

Since 2006, my ongoing *Postcards from Europe* series has assembled photographs and texts touching on conflict at the individual level in the context of migration. My interest in the treatment of migrants and refugees in the European Union and at its borders represents a radical departure from conventional reporting. My photographs show places where exclusion, xenophobia and violence have occurred – but empty of people. Each photograph is accompanied by a dry, detached and exhaustively researched explanatory text. Only in the course of reading does it become apparent why the place was worth photographing.

My method challenges the belief that photography objectively transmits reliable information requiring no context. My photographs avoid the shock effect of portraying violence and acquire significance through avoiding pathos and instrumentalisation.

Eva Leitolf, born in Würzburg, Germany, in 1966, studied at University GH Essen and the California Institute of the Arts. Her works, including German Images – Looking for Evidence, Rostock Ritz *and* Postcards from Europe, *have been shown in exhibitions across Europe and the United States. She is Professor of Fine Arts at the Free University of Bozen-Bolzano.*

© VG Bild-Kunst, Bonn 2022

Artist Statements & Biographies

p36 **AZADEH AKHLAGHI**

Is it possible that a moment becomes so tumultuous and critical that it breaks the linearity of time and lobs its dwellers into another historical moment? Can we come upon a radical crack in history and walk with the spirits of the past along our contemporary streets?

How about the opposite way? Can we detach from our everyday life and travel back through history? Not through memory or reading, but through our very flesh and blood?

Rather than a historical preoccupation, this project derives from the shock of the present and is a meditation on those possibilities.

Perhaps this is utopian daydreaming, imagining the simultaneity of ourselves and the dead in an essentially different time, the time that has not come yet.

Azadeh Akhlaghi, born in Shiraz, Iran, in 1978, graduated in computer science from RMIT University in Melbourne and now lives between there and Tehran. She has participated in exhibitions all over the world – from Tehran to Shanghai and Seoul, from Paris and London to Chicago and Wichita. In 2019, she was named the Robert Gardner Fellow at Harvard's Peabody Museum.

p38 **RITA LEISTNER**

Who will plant the billions of trees we need to combat climate change?

My portraits of tree-planters in Canada profile a subculture of professionals who can plant an astonishing 2,000–5,000 trees in a day. They are high-performance athletes, whose work requires extraordinary stamina and tolerance for pain. I was a tree-planter in my youth, some 30 years ago, and I returned to the forest to capture these little-known workers in action. I was able to 'temporally freeze' my subjects – to use the phrase applied to Caravaggio's kinetic portraits – imposing compositional precision and lighting that evoke a studio. These references place the planters among the great figures of art and history, amplifying the urgency of climate action in the process.

The work of Rita Leistner who was born in 1964 in Scarborough, Canada, and is based in Montreal, has been exhibited in nine countries and is in collections such as the National Gallery of Canada, Ottawa. Her acclaimed 2021 documentary, Forest for the Trees, *is part of a five-year-long multimedia project.*

p40 **POLLY BRADEN**

My participatory project *Holding the Baby* portrays the impact of government austerity measures on single parents from Bristol, London and Liverpool, highlighting their experience and resilience with portraits and narratives.

I was inspired and provoked by a United Nations report, which said that single parents have been hardest hit by austerity. These collaborative photographs – some taken during lockdown by the parents themselves – capture the families' sense of adventure, optimism, creativity and ambition, transcending their difficulties.

The photos are accompanied by excerpts from their conversations with the journalist Sally Williams, as well as by reflections on the idea of home, drawn together by the writer Claire-Louise Bennett. The individual stories of Fran, Jahanara, Charmaine, Aaron, Barbeline, Caroline, Gemma and Carike highlight the universality of their lives.

Polly Braden is a documentary photographer based in London, United Kingdom. She has exhibited her work widely across the country and internationally. Holding the Baby *was shown at the Arnolfini in Bristol in 2022. Her seven books include* A Place for Me: 50 Stories of Finding Home, *co-written with Sally Williams and published in 2022.*

p41 **MANDY BARKER**

CROWN 2.5L is a camera built from marine plastic debris recovered in nine countries around the world. The objects include a chopping board, a luggage tag and a poultry feeder washed up from the North Sea imprinted with the words 'CROWN 2.5L Taiwan'. The camera uses a reconditioned Schneider lens. A toy car wheel from Henderson Island in the Pacific turns the focus.

The journeys taken by the components reflect an amalgamation of disorder and concern, but also a chance coming-together of parts to create a new use for them. The images have passed through the cavity of a chicken feeder, so are not intended to be perfect, but rather reflect an imperfect world. They capture the pollution that the camera was constructed from.

British photographer Mandy Barker has won global recognition for her work on plastic pollution. It has appeared in publications including National Geographic *and* Vogue, *as well as at venues including the UN Headquarters in New York. She has been nominated for the 2018 Deutsche Börse Photography Foundation Prize.*

p42 **GEORGINA GOODWIN**

In March 2020, the first Covid-19 lockdown was a welcome break for me after 15 years of non-stop photography with a new baby and a bubble of uninterrupted time to learn how to be a mother.

But there were challenges. For four months, I hunkered down with my husband and baby girl. Time slowed, small moments became the Big Moments. I wanted to see how other women photographers were managing, so I invited 40 from around the world to take part in my *New Normal* project, each capturing a moment of their life at the same time as me in mine.

Some of my personal moments during those deep months are shared here as diptychs: a pairing of an 'Up' and a 'Down'.

Georgina Goodwin is a documentary photographer focusing on the environment, women and social issues. She is known for her work on Kenya and on refugees, which won the 2019 British Journal of Photography Portrait of Humanity Award. Her work has been published widely and exhibited in Times Square, New York, Tokyo and the Louvre, Paris.

p44 **RINKO KAWAUCHI**

I have travelled repeatedly and taken photographs to gain a solid sensation that I am alive on this planet. I have gathered them into series, such as *Ametsuchi* and *Halo*.

Then, in 2019, I went to Iceland. In the cavernous space inside a dormant volcano, light hit the surface and vivid shades of yellow, blue and purple were reflected back. Above me, I saw light shining through the vulva-like opening of the crater. I felt as if my existence was that of a foetus, enveloped within Earth, and sensed a connection to this planet that I had never felt before.

The title, *M/E*, stands for Mother Earth. In this crater I sensed myself and Earth mirroring each other, as if we had become one.

Rinko Kawauchi was born in 1972 in Shiga Prefecture, Japan, and lives and works in Tokyo. She has published numerous photobooks, most recently Des oiseaux *in 2021. She has held solo exhibitions in Paris, São Paulo, Paris, London and Amsterdam, as well as in Japan. She was shortlisted for the Prix Pictet* Fire *in 2021.*

p45 CHLOE DEWE MATHEWS

For the past ten years, I have made work about the increasingly fraught relationship between human civilisation and the landscape it occupies. In recent projects such as *For a Few Euros More* and *In Search of Frankenstein*, I have used photography to project the past onto the present, allowing for multiple narratives to be explored side by side. In these projects, as well as *Thames Log* and *Caspian: the Elements*, I attempt to offer a fresh perspective on contemporary issues around landscape and the environment.

Chloe Dewe Mathews is an artist, photographer and filmmaker, whose work is held in numerous collections and has been exhibited at Tate Modern, London, the Irish Museum of Modern Art, Dublin, and Staatliche Kunstsammlungen, Dresden. She was a Gardner Fellow at Harvard's Peabody Museum in 2014. Her four monographs include Thames Log, *published in 2021.*

p46 ALIXANDRA FAZZINA

Ten years on from my book *A Million Shillings – Escape from Somalia*, I returned to the Gulf of Aden to investigate a new political landscape. It is a unique microcosm of today's worldwide flows of human traffic. In no other place have perpetual cycles of conflict and disorder forced so many people into successive rotations of migration in such a small space. Against the background of refugees fleeing for their lives from Yemen, thousands of people have been seemingly lured to danger by the almost mythical pull of a people trafficker and crime lord who may or may not exist. *Yemen Contraflow* is a parable for our times, untangling powerful metanarratives that cloak the links between human smuggling and protracted conflict.

Alixandra Fazzina is an author and visual artist who focuses on underreported conflicts and their humanitarian consequences. She began as a war artist, going on to work as a frontline news photographer. A Million Shillings – Escape from Somalia, *which follows people-smuggling routes, was shortlisted for the Prix Pictet* Disorder *in 2015.*

p48 DIANA MARKOSIAN

Santa Barbara is a personal project exploring the profound sacrifice made by my mother to abandon her country and husband in search of the American Dream. Following the collapse of the Soviet Union, my family fled to the coastal town of Santa Barbara, California, made famous in Russia when the 1980s soap opera of the same name became the first American show to be broadcast there. It was also home to a stranger who would marry my mother and take the place of my own father. Through a cast of actors, a set designer and a script, I have reenacted memories from my childhood as a way of processing my past.

Diana Markosian was born in Moscow, Russia, in 1989. Her intimate and experimental approach to storytelling blends documentary and conceptual practices. Her first monograph, Santa Barbara, *published by Aperture, was selected by* Time *and the Museum of Modern Art, New York, as their top photobook of 2022.*

p49 CRISTINA DE MIDDEL

Journey to the Center is a series that borrows the atmosphere and structure of the Jules Verne book *Journey to the Center of the Earth* to present the Central America migration route across Mexico as a heroic and daring journey rather than as an act of fleeing.

In this version of the journey, the starting point is Tapachula on the southern border of Mexico with Guatemala, and the journey ends in Felicity, a small town in California that has officially designated itself the centre of the world. The absurdity of this landmark, from where you can see the border fence, just adds a layer of dystopian disappointment, where the final destination in this heroic quest is a little roadside tourist attraction.

With a language that combines straight documentary photography with constructed images and archival material, the multilayered narrative is more complete than the simplistic approach to the complex phenomenon of migration provided by media and official reports.

Cristina de Middel is a Spanish photographer who lives in Mexico and Brazil. Her work investigates the medium's ambiguous relationship with truth. After a ten-year career as a photojournalist and humanitarian photographer, she produced the acclaimed series The Afronauts *in 2012. She has had more than 13 books published.*

Courtesy of the artist and Magnum Photos

p50 JOANA CHOUMALI

In Agni, a language spoken in Côte d'Ivoire, *Alba'hian* means 'the first light of day'. Every morning, I wake at 5 am to walk and photograph the landscapes, the buildings, the shapes slowly revealing themselves. What started as training for a trek in Asia became a ritual of introspection that accompanies me even when I travel abroad. This practice of observation has made me aware of the shift in my perceptions.

Using collage, embroidery, painting and photomontage, I superimpose onto the photographs layers of ethereal fabrics intertwined with silhouettes of passers-by: toiles evoking my morning experiences. Gradually, I have come to understand that what I was hoping to find in my journeys abroad, I finally discovered in my own home.

Joana Choumali, born in 1974, is a visual artist/ photographer based in Abidjan, Côte d'Ivoire. She studied graphic arts in Casablanca, Morocco. Choumali has exhibited her work around the world and in 2019 became the first African winner of the Prix Pictet. Her book, Hâábré, *was published in 2016.*

p52 LÉONIE HAMPTON

In *A Language of Seeds*, I capture the beauty of the natural world while addressing the climate crisis through the relationships between hand, body, mouth and the food I grow.

Gardening is reciprocity in action. As Rebecca Solnit writes, 'Soil has the potential as a site to bring forth crops; which may be crops of ideas or community, ideas of resistance, rebirth or pleasure. You can argue that vegetable seeds are the seeds of revolution.'

In *Candide*, Voltaire writes that 'we must cultivate our own garden'. Solnit asks, 'Is this a statement of defeat or is it a manifesto? ... If planting vegetables allows you to retreat from supermarkets and factory farming, it is a political act and a political victory, maybe even an attack in the guise of a retreat.'

Léonie Hampton works in Devon, United Kingdom. In 2022, she had a retrospective at Foto Forum, Bolzano. She won the Foam Paul Huf Award in 2009, and her book A Language of Seeds *was nominated for the 2011 Deutsche Börse Photography Foundation Prize. She is part of the artist collective Still/Moving and teaches at the London College of Communication.*

Artist Statements & Biographies

p53 JILLIAN EDELSTEIN

Since 2010, I have been hunting for a lost branch of my family evicted from Latvia in 1915. They eventually found a new home in Ukraine. This prompted me to look at the plight of the estimated 82.4 million refugees worldwide, fleeing armed conflict, persecution or, increasingly, global warming. Refugees should be protected by international law. They should not be expelled or returned to situations where their life or freedom would be under threat.

Visiting the Boat Graveyard on Lampedusa, finding the instructions on how to manoeuvre the boat that smashed into the rocks on Linosa, I saw evidence of their plight – human spillage in the environment. It is untenable, unsustainable on so many levels and contradicts the so-called concept of international security and protection.

Jillian Edelstein, born in South Africa and based in London, works in portrait and documentary photography. She was named a 2021 Hasselblad Heroine. Generations: Portraits of Holocaust Survivors *was exhibited at the Imperial War Museum, London, and Unesco, Paris, in 2021–22. Her work has been published and exhibited worldwide. The National Portrait Gallery, London, holds more than 100 of her portraits.*

p54 MARGARET COURTNEY-CLARKE

Caged is an ongoing project exploring the use of constraining, protecting and demarcating cages across Namibia. The wide terrain, where nomadic Bushmen and animals used to move freely, is increasingly fenced, systematically divided by internal and external socio-economic and political forces. Organic arteries of migration are cut off and the geometry of the rectangle entraps humans, animals and plants in its defining limits.

Climate change in the form of a seven-year drought has stripped the Namibia desert bare. Scientific research subjects, such as the endemic plant *Welwitschia mirabilis*, are penned in to study and protect them. A corrugated shack, encircled with razor wire, hides the underground currency exchange of the drugs economy. A rain gauge, inactive for years, appears in the background of an inadvertently captured stone in a grassless cage.

Margaret Courtney-Clarke lives and works in Namibia, where she was born in 1949. She has spent four decades working as a photographer in Italy, the United States and across Africa. She was a Prix Pictet Hope *finalist in 2019. More than 200 exhibitions of her work have been held globally. Her publications include* Cry Sadness into the Coming Rain, *published in 2018.*

Courtesy of the artist and SMAC Gallery, Cape Town

p56 TARYN SIMON

In signings of political accords, powerful men flank floral centrepieces curated to convey the importance of the signatories and institutions they represent. An image of Mussolini, Hitler, and Chamberlain at the 1938 Munich Conference sitting around a large bouquet got me thinking about the performance of power, with nature as a castrated accessory; this silent witness listening to those men and their belief in their abilities to control economies, geographies and the evolution of the world.

I worked with a botanist to identify the flowers in archival images of signings and then recreated the bouquets. Many of the agreements in this project represent broken promises – declarations that have been violated and withered.

Taryn Simon, born in 1975 and based in New York, United States, combines mediums from photography and sculpture to text, sound and performance. Her work has been exhibited most recently at the Hamburger Kunsthalle and the New York Public Library in 2021–22. She has received a Guggenheim Fellowship and a Photo London Master of Photography award.

© Taryn Simon. Courtesy of Gagosian

p57 HEATHER AGYEPONG

'Unless we learn the lesson of self-appreciation and practise it, we shall spend our lives imitating other people and deprecating ourselves.' Those are the words of celebrated African-American vaudeville artist Aida Overton Walker, the subject of *Wish You Were Here*. She was known as the Queen of the Cake Walk, a dance craze originally performed by enslaved people that swept America and Europe in the early 1900s.

Overton Walker reinterpreted the dance into one of elegance and skill. She was outspoken about how she wanted to be represented, challenging problematic narratives of black performers.

Often-grotesque postcards of cake walk dancers were distributed around Europe – and *Wish You Were Here* reimagines these images. By embodying Overton Walker as guide, ancestor and advocate, the series uses satirical commentary and depictions of radical self-worth to disrupt the roadblocks affecting our collective mental health.

Heather Agyepong, based in London, United Kingdom, focuses on mental health and wellbeing, invisibility, the diaspora and the archive. She has worked in photographic and performance arts since 2009. In 2021, she won the Nikon × Photo London Emerging Photographer Award and has won or been nominated for other prizes, including the Prix Pictet.

p58 DORNITH DOHERTY

Spurred by the completion of the Svalbard Global Seed Vault, I began *Archiving Eden* in 2008 to explore the role of seed banks in the face of climate change and species extinction. The gravity of climate change and political instability has created the need for this remote 'Doomsday Vault' near the North Pole. Collaborating with scientists at seed banks around the world, I discovered the complex issues relating to control of one of the world's most basic resources. Documentary images record the spaces and technological interventions required to store the seeds and clones. Digital collages I made with X-ray images using on-site research equipment are a more poetic exploration of individual seeds and plant samples.

Dornith Doherty, a 2012 Guggenheim Foundation Fellow, is an American artist working primarily with photography, video and scientific imaging. Since 2008, she has collaborated with scientists on themes of biodiversity preservation. She has held numerous artist-in-residencies in the United States, Canada and the United Kingdom. Her work has been shown widely and is held in numerous collections.

p59 UTA KÖGELSBERGER

I initiated the multifaceted *Fire Complex* after the 2020 Castle Fire in California burned over 174,000 acres of Sequoia National Forest, including 14 per cent of the world's giant sequoia population and the community of Sequoia Crest.

Fire Complex explores the complex underbelly of forest management. It observes the devastating impact of wildfires, bringing together photography and video to raise momentum and resources for regenerating forests. The project has been exhibited on paper and digital billboards across the United Kingdom and the United States. In 2022, it was exhibited as a video installation at the Royal Academy, London.

The project cuts across political divides deeply entangled with wildfire and forest management. It has organised replanting in collaboration with Sequoia Crest and other local communities, volunteers, government and private sponsors.

Uta Kögelsberger is based in London, United Kingdom, and California. Her socially and politically engaged work has been exhibited across the United Kingdom, in California, New York and at Les Rencontres d'Arles. It is held in collections including the Museum of Fine Arts, Houston, and Los Angeles County Museum of Art. Fire Complex *won the Royal Academy's 2022 Charles Wollaston Award.*

TOMOKO KIKUCHI

My series *Funerals under Neon Lights* focuses on transgender people's vital role in funerals in rural China. Eccentric performances by transgender performers, little people, singers in bikinis, magicians and acrobats take place under gaudy neon lights.

The strong contrast of lightness and darkness casts a captivating melancholy, while the contrast between these moments of death and the neon-lit performances highlights evolving concepts of life and death.

These photographs portray transgender people's role as connectors, crossing the boundaries of sexual dichotomy and thus of life and death. They reveal how liberal gender perception and gender-queer culture are alive in Asian tradition. This scene challenges our understanding of Asian tradition as typical heterosexual patriarchy and enables us to perceive the liminality of tradition beyond Asian modernisation.

Tomoko Kikuchi is a Japanese-born artist, who has investigated the impact of rapid social change in China on notions of gender, family and social development over 15 years. I and I, created in 2005–13, and Lost Boundaries from 2012 are series of photographs and video works about young Chinese LGBTQ+ people.

MAJA DANIELS

This series focuses on the history and myth of 12-year-old Gertrud Svensdotter, accused of walking on water in Älvdalen, Sweden, in 1667. This began the mass hysteria and horror of Sweden's witch hunts. In this series, I use photography as a tool for myth-making. Oral traditions are often based on myths and folklore as a way of learning and sharing. However, myths are open to interpretation and refuse to be locked away. Photographs function similarly. Their core lies somewhere in the unseen or its silent associations. I create new mythologies of sorts. The images become a way to challenge historical constructs and show how a visual narrative can remake our relationship with the past, present and future.

Maja Daniels was born in Sweden in 1985. She has received numerous awards and fellowships and is a lecturer in film at the University of Gothenburg. Her first book, Elf Dalia, was published in 2019. She has also made a number of short films, including Hauntings, which premiered in 2020.

ILIT AZOULAY

I am concerned with reassembling dislocated images, desegregating narratives and undermined representations into a comprehensive, sensitive and protean body of work. In my photographs, collages and installations, I bring to light forgotten or undermined objects.

For *Mousework*, I conducted comprehensive research into hysteria, as invented and depicted by the 19th-century French neurologist Jean-Martin Charcot. I also used the keyword 'hysteria' for a search that produced over 3,000 images of women, often used by pharmaceutical or insurance companies.

Drawing connections between images of 'hysterical' women and circumscriptions of female identity, *Mousework* characterises the 19th-century definition of hysteria as the persistence of a system aimed at maintaining the patriarchal order, which continues to this day. My series proposes a powerful female vision for a possible post-patriarchal era.

Ilit Azoulay, born in 1972 in Jaffa/Tel Aviv, Israel, lives in Berlin. Her work has been exhibited around the world, including in the Israeli Pavilion at the 2022 Biennale di Venezia. Her awards include the Rencontres d'Arles Discovery Award, and she was a Prix Pictet Disorder finalist in 2015. Her most recent book is Queendom, published in 2022.

© Ilit Azoulay. Courtesy of the artist and Braverman Gallery

AN-MY LÊ

I started *Silent General* in 2015 when I felt war was coming back to the home front and our democracy was being threatened. I was invited to photograph the set of this big Hollywood historical film, *Free State of Jones*, and I immediately realised these photographs could be the foundation of a larger discussion, connecting the legacy and myths of the civil war to our socio-political moment. My viewpoints speak to experiences of a shared past in an unfolding present.

My background spurred curiosity in these situations as so many of the photographs I saw of Vietnam after I left were close-ups of conflict taken by foreigners. But I am not a war photographer. I find it more interesting and much more slippery to work with a side-glance view.

An-My Lê, born in 1960 in Saigon, Vietnam, moved to the United States with her family in 1975 as political refugees. She was educated at Yale and Stanford and lives in New York, where she teaches at Bard College. She has held numerous shows internationally. In 2020, the Carnegie Museum of Art, Pittsburgh, held a comprehensive exhibition of her work.

© An-My Lê. Courtesy of the artist and Marian Goodman Gallery

TOMOKO SAWADA

I always focus on the relationship between appearance and inner face, both of myself and of others. This theme has affected me greatly, even if it does not lead to any definite conclusion. In creating my work, I have never tried to disguise myself in a way that refers to another real individual. I try to become someone different from myself – and to do that, I just change my appearance.

The *Bloom* series was serialised in the beauty magazine *etRouge*. If someone saw my work and bloomed, I would be glad. It would also make me happy if someone who had lost that spark of excitement about makeup were able to regain it.

Tomoko Sawada was born in Kobe, Japan, in 1977. Her many awards include the Kobe Nagata Culture Prize in 2019. Her most recent exhibition, To Be Bewitched by a Fox, was exhibited at the Tokyo Photographic Art Museum in 2021. Her work is in more than 20 collections, including the Getty Center, Los Angeles, and The National Museum of Modern Art, Kyoto.

LARA ATALLAH

34.5531° N, 18.0480° E is a project started in 2016, named after coordinates in the middle of the Mediterranean. It consists of Polaroids made along the European and Asian coastlines of the sea. The Mediterranean, once perceived as a place of recreation, has become a route for refugees aboard over-packed rubber boats. Many never arrive, resulting in dozens of deaths at a time. For the survivors, the Mediterranean represents a stage in a perilous journey; for others, a final resting place. Polaroids by definition are difficult to control and unpredictable – like their subject, the sea. Each photograph was deliberately damaged during the first 30 seconds of development to produce distorted seascapes. The photographs, devoid of humans, depict the sea as a sombre place.

Lara Atallah is a New York-based artist and writer. Her work has been exhibited internationally and is in collections including the Onassis Foundation, Athens, and the Metropolitan Museum of Art, New York. Her first book, Edge of Elysium, Vol. 1, was published in 2019. Her first poetry collection is forthcoming in 2023.

Artist Statements & Biographies

p68 **PENELOPE UMBRICO**

I focus on the ubiquitous presence of screen devices in our lives and the weight of their afterlife. An estimated 53.6 million tonnes of e-waste was discarded worldwide in 2019 and only 12 per cent of this was recycled. I collect images of technology for sale on eBay and Alibaba and aggregate them to create virtual landfill – in which the televisions depicted in my project, *TVs from Craigslist*, will end up – mapping the changes in these technologies and our relationship to them through time.

Penelope Umbrico was born in Philadelphia, United States, in 1957 and studied in Toronto and New York. Her work has appeared on the cover of The New York Times Magazine. *She has exhibited worldwide from the Museum of Modern Art, New York, to the Pingyao International Photography Festival, China. Her many awards include a Guggenheim Fellowship. Her most recent book is* Everyone's Photos Any License, *2019.*

p70 **RENA EFFENDI**

A column of Ukrainian armoured vehicles drove past the ruined village of Zalissia. 'Look at them go, our defenders!' Irina Kovalenko, 72, exclaimed with tears in her eyes. Irina's home in Zalissia had been reduced to rubble. She moved back on 1 May, made her bed and slept amid the debris.

I visited several villages in Kyiv Oblast to watch people returning to the ruins of their homes. It seemed a task well beyond their means, but they persevered, sweeping the rooms and tending to their small plots.

In Bohdanivka, Yefrosinya planted carrots in front of the burned village school. 'I hope one day I'll have enough food to share with those who'll need it the most,' she said, smiling.

Azerbaijani photographer Rena Effendi has won numerous prizes, including a Prince Claus Award in the Netherlands. She was shortlisted for the Prix Pictet in 2012 and 2018. Her work has been published widely, including in Newsweek, Le Monde *and* Marie Claire. *Her two monographs focus on the impact of the oil industry.*

p72 **SOPHIE GERRARD**

The Flows, from the Norse 'floi' meaning 'flat, deep, wet land', explores the gentle, undulating Flow Country in northeast Scotland, the largest expanse of blanket peat bog in the world.

Although peatlands cover only three per cent of the planet's land surface, they hold almost 30 per cent of terrestrial carbon, twice as much as all the world's forests.

In the 1980s, tax incentives to the rich resulted in vast areas of the Flow Country being planted with spruce trees, which drained and ultimately killed much of the bog. Over 80 per cent of the United Kingdom's peatlands have been damaged by economic exploitation.

My photographs look at how this precious environmental resource has been desecrated and denuded, as well as how these almost magical places are being reinvigorated through careful conservation.

Sophie Gerrard, born in 1978, worked in environmental sciences before studying photography in Edinburgh and London, United Kingdom. Her prizes include a Jerwood/ Photoworks Award, and she has been nominated for the Prix Pictet several times. Her work has appeared in The Guardian, The New York Times *and elsewhere, as well as in numerous exhibitions. It is held by the Equinor Art Programme, Norway, the Sir Elton John Collection, London, and others.*

p73 **GOHAR DASHTI**

Through my highly stylised, densely poetic observations of human and plant life, I explore the innate kinship between the natural world and human migration. I am fascinated with human geographical narratives and their interconnection with my own experiences. I believe that nature is what connects me to the multiple meanings of 'home' and 'displacement', both as abstractions and as concrete realities that delineate and contour our existence.

The artistic practice of Gohar Dashti, who is based in Tehran, Iran, consists of lens-based media, photography and video. Her works are in museum collections such as the Victoria and Albert Museum, London, the Mori Art Museum, Tokyo, National Gallery of Art and the Smithsonian, Washington, D.C.

p74 **ZEYNEP KAYAN**

I explore self, body and the human condition through the potentials of repetition as an instrument. I experiment on variations of an image, a movement, a gesture, a sound or a line of words to create rhythm and tempo. I work with video, photography, sound and performance. I am interested in gestures that are connotative, restored behaviours, the action of invisible forces on the body through repetition. I am interested in the way things repeat, but never repeat in the same way. I am interested in exhaustion, in how things alter and separate gradually, in rituals, in orchestra, in inertia and movement, in dressing and undressing continuously, in the place the personal occupies. I am interested in the dance that goes nowhere, in concentration and uninterrupted contradiction.

Zeynep Kayan was born in Ankara, Turkey, in 1986. Since September 2022, she has been an artist in residence at the Rijksakademie van beeldende kunsten, Amsterdam. She has held solo shows recently at Zilberman Gallery, Berlin, Zona Maco, Mexico City, and Zilberman Gallery, Istanbul. Her book Untitled *was published in 2018.*

Courtesy of the artist and Zilberman Gallery

p75 **MYRIAM ABDELAZIZ**

There is a mental space where you are about to lose yourself, where you are on this edge: where you don't know what is right from wrong and what is real or not.
A lonely and painful place where confusion and doubt have taken over your mind.
I have been there.

Myriam Abdelaziz is a French-American photographer born in Cairo, Egypt, and now based in New York. Her awards include the LensCulture Emerging Talent Awards. She has been published in Newsweek, Marie Claire, *the* British Journal of Photography *and elsewhere and has exhibited in the Middle East, the United States and Europe. Her photobook,* We the People, *was published in 2021.*

p76 **SUSAN DERGES**

Since I was shortlisted for Prix Pictet *Water* in 2008, I have continued to develop this theme, making images concerned with the potential of metaphor for articulating our changing relationships with the natural world.

Tide Pool 39 is from a group of works from 2014–15 that focused on the intertidal zones of north Devon in the United Kingdom. *Wake* comes from a 2019 commission displayed at the Royal Museums Greenwich, London. I made a series in response to the Armada Portrait of Queen Elizabeth I, intended as photographic metaphors for the impact of that time.

Since lockdown, my work has focused on our role as nurturers of, rather than being nurtured by, the natural world. In *Seed Constellation*, the irrepressible creative energy and movement towards existence is shown in a blue void of suspended potential.

Susan Derges spent six years working in Japan in the 1980s, when she developed the camera-less photographic techniques for which she is known. In 2010, she published her monograph, Elemental, *based on 25 years of image-making. Recent exhibitions include* Mortal Moon *in Greenwich, London, in 2019. Her work is held in museums and collections worldwide.*

Courtesy of the artist and Purdy Hicks Gallery

p78 **NADIA SHIRA COHEN**

Mayan beekeepers believe their native *Meliponini* stingless bees were a gift from the god Ah Muzen Cab. They have made the Yucatán Peninsula one of the world's largest producers of honey.

However, in the past few years, hives have been disappearing and the honey has been contaminated by pesticides. In 2011, the Mexican government began subsidising farmers to grow genetically modified soy in the region. These farmers were Mennonite Christians, who could afford land and machinery.

Because of its effect on the bees and honey, as well as human health, Mexico's Supreme Court banned genetically modified soy in 2015 – yet farmers continue to cultivate it and are destroying Yucatán's rainforest to make room for their crops, endangering the health of Mennonites and Mayans alike.

Nadia Shira Cohen is a documentary photographer born in Boston, United States, in 1977 and is now based in Rome, Italy. She is a World Press Photo winner and her work has been exhibited in the United States, Russia, Belgium, Spain, Mexico, Italy and Peru.

p79 **LIZA AMBROSSIO**

A while ago, I decided to change my life in the most extraordinary way. I remembered my mother's words the last time I saw her, when I was 16: 'Good luck to you and, believe me, I really hope that you are very strong and bold so as to have no mercy when the time comes to destroy your body and crush your soul.'

After an overwhelming emotional crisis, I began a psychomagic sequence of images, adhering to what Jacques Derrida called *feu la cendre*, which roughly translates as 'cinders'. I am communicating with what remains after life; my series is an act of entropy and exhaustion. The cinders are linked to fire and death as well as life; they are the being that recognises itself.

Liza Ambrossio, born in 1993, lives and works in Spain, France and Mexico. She has won numerous prizes, including the Nuevo Talento Fnac de Fotografía award in Spain and Voies Off in Arles. She is currently working on her third photobook, The Witch Stage.

p80 **VANESSA WINSHIP**

I made these images as part of an artist's residency on the west coast of England. I remain concerned with young people, their education and their ability to be properly nourished, both physically and intellectually. Standing together in hard times was what I was thinking about.

I explored the length and breadth of the shoreline, historically connected with mining, farming and fishing, migration and displacement. This is the industrial counterpart to Cumbria's picturesque Lake District. The decline of these industries hit the coast hard, and it is now one of the United Kingdom's most deprived areas. A single rail line runs by Sellafield nuclear power station.

Being together was made impossible because of a pandemic that impacted so powerfully on so many lives.

British photographer Vanessa Winship, born in 1960, is the author of seven monographs, most recently Snow, *published in 2022. Her awards include two World Press Photo 1st prizes and the 2011 Fondation Henri Cartier-Bresson Award. Her work has been exhibited internationally, including at the National Portrait Gallery, London, and Fundación MAPFRE, Madrid.*

p81 **JEONGMEE YOON**

The Pink and Blue Project began with my six-year-old daughter, who loves pink, wants to wear only pink clothes and owns only pink toys and objects. Most other little girls in the United States and South Korea also love pink, seemingly regardless of cultural background. It results from the power of pervasive commercial advertisements such as those for Barbie and Hello Kitty. Consumers are directed to buy blue for boys and pink for girls. Blue has become a symbol of strength and masculinity, while pink symbolises sweetness and femininity.

To make this series, I visited children's rooms and displayed their possessions to show the viewer how children and their parents, knowingly or unknowingly, are influenced by advertising and popular culture.

JeongMee Yoon was born in Seoul, South Korea, in 1969. Her numerous prizes include the Ilwoo Photography Award in 2018. Her work has been published in The New York Times *and* National Geographic *and on the cover of* LIFE. *Her book,* The Pink & Blue Project, *was published in 2018.*

p82 **CLAUDIA JAGUARIBE**

These images are part of a series which tackles sustainability through the theme of resilience and how nature, given a chance, comes back to life. They were constructed from photos of places shown against inhospitable backgrounds. A burned-out landscape turns into an oasis reclaimed by luxuriant palms, monsteras and philodendrons. An abandoned brick building gives way to flamboyant anthuriums, heliconias and ferns.

With their inbuilt contrasts, the images point to a better, alternative future. We can no longer ignore climate change or the damage caused by excessive building and environmental devastation. We need reminding of the power that nature exerts on our wellbeing. The contrast between background and foreground is accentuated by unrealistic perspective, fusing fantastic realism with modernist surrealism to create a new vision of reality.

Claudia Jaguaribe was born in Rio de Janeiro, Brazil, and lives there and in São Paulo. She holds a degree from Boston University. Her work focuses on urban and environmental issues and is in collections in Brazil, Paris, Rome, Brussels and elsewhere. She is the author of 20 books.

Artist Statements & Biographies

p84 STEFFI KLENZ

The Maiden Lane Estate in Camden, London, was a visionary, postwar, modernist social housing scheme which, because of financial pressures, was only partly realised.

Tensed Muscles explores the relationship between the architectural promise of modernist living and the reality of living in Maiden Lane, which by the late 1990s was known as a poor, violent and rundown estate with most of the council homes sold off.

My images combine archive photographs, hand-drawn medical illustrations of tensed muscles, photograms created from the estate's building shapes, as well as yardsticks and rulers depicting the body measurements of residents.

I use ideas of the 'phantom limb' and 'conversion disorder' as metaphors for the disappearance of social housing schemes, mainly privatised in a process started by Margaret Thatcher.

Steffi Klenz, born in Germany in 1979 and based in London, has exhibited internationally from the British Museum to the Los Angeles Center for Digital Art. Her work has appeared in publications including Art Review *and* Portfolio Magazine. *The most recent of her many public commissions,* Tensed Muscles, *was for Camden Alive as part of the London Borough of Culture project.*

p85 ALEX PRAGER

I chose these pictures based on my ever-evolving urge to create a sort of allegory about society today – all the chaos and turmoil lurking beneath the surface of America. These images capture the unrest I felt around the last three years, the feeling that something was on the verge of breaking and from there everything else would collapse. We are in such unstable times that I wanted to bring humour and beauty to this catastrophe. By mirroring what I was seeing in the world, I could have a better understanding of it.

Born in 1979 in Los Angeles, Alex Prager is an American artist and filmmaker who creates elaborately staged scenes inspired by a wide range of influences, including Hollywood, experimental films, popular culture and street photography. Her work has been exhibited globally and is in collections including the Los Angeles County Museum of Art and the Museum of Modern Art, New York.

© Alex Prager. Courtesy of Alex Prager Studio and Lehmann Maupin, New York, Hong Kong, Seoul and London

p86 MITRA TABRIZIAN

On a planet we have neglected and exploited, we reel from the consequences: pandemic, pollution, climate change and war. Pandemics as global disasters in the past have turned the world upside down. As Jean Baudrillard wrote, 'Prophesying catastrophe is incredibly banal. The more original move is to assume it has already happened.'

Covid-19 can be seen as a late lesson from an early warning. Environmental degradation has increased the risk of pandemics and other disasters.

The work presented here takes a conceptual approach. The conventional view that everything is going to be all right is upended and the precariousness of our existence is revealed. Yet, we ignore the urgency. Our attempt to sustain an unsustainable world fails. Silence reigns over the image, a silence of explanations unknown.

Mitra Tabrizian is an Iranian-British artist and filmmaker. Her photography is represented in major international collections. She has held exhibitions at venues including Tate Britain, London, and the 2015 Biennale di Venezia. She received the Royal Photographic Society Honorary Fellowship in 2021. Her critically acclaimed debut feature film, Gholam, *was released in 2017.*

© VG Bild-Kunst, Bonn 2022

p88 PAOLA DE PIETRI

It is the plain of the River Po. My two series intersect as they unfold.

In the first series, large-format images in black and white show trees and abandoned, ruined farmhouses. The second, featuring small-format colour images, depicts situations linked to atmospheric variability and the annual cycle. The non-random distribution of the houses and trees responded to well-defined economic and social requirements, which held out until around 40 years ago – and I was witness to it. The houses now seem relegated to the sphere of archaeology and the trees are free to grow naturally. The colour series features riverbanks, grasses, crops, birds, wild flowers and skies, in which perception of the plain is linked to the vital, sensorial and atmospheric aspects of the natural cycle.

Paola De Pietri, born in Reggio Emilia, Italy, in 1960, focuses on humans' relationship with space and its temporal dimensions in both urban and natural landscapes. She has held exhibitions across Europe. Her books include Da inverno a inverno ('From Winter to Winter'), *published in 2021. She won the Albert Renger-Patzsch Prize in 2009.*

p89 JULIE BOSERUP

I work primarily with collages that explore space and architecture by renegotiating found materials and vintage architectural photos. My transformative process points to sustainable strategies of reuse, suggesting new views on our surroundings, identities and the shared history we move in.

In *Temporary Futures*, I explore an old, abstract future that has not been realised. The collages are based on photos from a vintage book on the 1939–40 New York World's Fair, staged in the wake of the Great Depression and just before America's entry into war. It attempted to look to a future beyond all this, opening with the slogan 'Dawn of a New Day'.

I find the book even more relevant today, when it can be so hard to believe in a bright future.

Julie Boserup is based in Copenhagen, Denmark. She graduated from London's Chelsea College of Arts in 2002. She has held exhibitions in Denmark at the National Museum of Photography, Copenhagen, and elsewhere, including at Sous Les Etoiles Gallery, New York. She is also known for public art installations. Her latest book is Transformer, *published in 2022.*

© VG Bild-Kunst, Bonn 2022

p90 ALETHEIA CASEY

The bushfires that tore through Australia in 2019 and 2020 destroyed over 10 million hectares of land. Australia is my home, but I watched the news from cold, rainy London, where I live, sick with anxiety as the flames came closer to my parents' home. Politicians faltered and stammered, unable to adequately address the question of climate change or the roles of damming, mining and coal exportation in this catastrophe.

The only way I could combat my frustration and anxiety was to produce this work. I took existing prints of what are now the sites of fires and painted them with inks and oils, reworking them to represent my fear and anxiety. The interference of my brushstrokes became a mirror of human intervention in nature, my own hand attempting to control the uncontrollable.

Aletheia Casey is based in Sydney and London, where she teaches at the London College of Communication. She has exhibited at the National Portrait Gallery in Canberra and at galleries in London and Heerenveen, the Netherlands, among other places. In 2021, she was named a winner of the Head On Landscape Award and Photo Collective's Stories award.

p92 NICI CUMPSTON

We are Barkandji, river people belonging to the Barka, our name for the Darling River. The Barka and the Murray connect in the Murray–Darling Basin and flow out to sea near Goolwa, South Australia. This catchment produces one third of Australia's food and is the cultural responsibility of 40 First Nations peoples.

The title *Oh My Murray Darling* is a play on words, a lament to the state of the basin. *Barka Messenger* was created walking along the backwaters of the Murray, while *Great-grandmother Barka* pays tribute to my Barkandji family.

The rivers are our livelihood; they support us with food, water and shelter. We rely on them to sustain us physically, emotionally and spiritually – and, in turn, it is our responsibility to care for them.

Nici Cumpston studied at the University of South Australia, Adelaide. She has exhibited nationally and internationally, and became Inaugural Curator of Aboriginal and Torres Strait Islander art at the Art Gallery of South Australia, Adelaide, in 2008.

Courtesy of the artist and Michael Reid Gallery

p94 LAURA EL-TANTAWY

On 11 June 2010, 35-year-old cotton farmer Sanjay Sarate said as he stumbled to the ground, 'I've taken pesticide … I'm going to die.' He was one of more than 300,000 farmers who have committed suicide in India since 1995. Many had borrowed to improve efficiency but could not pay off their debts due to crop failure. Their plight reflects the immense costs of India's transition. My grandfather Hussein is my inspiration. He was a farmer in Egypt's Nile Delta, whose devotion to his land eventually annihilated him. I have documented farmers in India, Egypt, Nepal, Ireland, the United Kingdom, Peru and the Palestinian Territories to show the collective vulnerability of a farmer today. *I'll Die For You* meditates on a life where the fate of man and land is intertwined as one.

Laura El-Tantawy is a British-Egyptian documentary photographer, bookmaker and mentor. In 2005, she moved to Cairo and started In the Shadow of the Pyramids, *shortlisted for the 2016 Deutsche Börse Photography Foundation Prize. She received the 2020 W. Eugene Smith Grant and the 1st Prize PhMuseum 2020 Women Photographers Grant for her project* I'll Die For You.

p95 NOÉMIE GOUDAL

My practice involves the construction of ambitious, staged, illusionistic installations within the landscape using film, photography and performances. My rigorous research examines the intersection of ecology and anthropology.

Post Atlantica, my latest multi-chapter body of work, questions the evolution of the landscape from a geological – rather than human – perspective, measured in millions of years. This timescale reveals geographies to be momentary states in continuous flux. The works unravel an artistic dialogue with the field of paleoclimatology, analysing climate and geology to understand our planet's trajectory. I ask the viewer to consider the evolution of the landscape and how we situate ourselves within it, and to challenge our ability to reconcile an ever-changing intellectual conception of the natural world with the world as it is.

Noémie Goudal was born in 1984 in Paris, France, where she is based. She gained a master's degree at the Royal College of Art, London. She has held numerous solo exhibitions internationally, most recently at Les Rencontres d'Arles in 2022. Collections holding her work include the Centre Pompidou, Paris; the Saatchi Gallery, London and Kiran Nadar Museum of Art, Delhi.

© VG Bild-Kunst, Bonn 2022

p96 JANELLE LYNCH

Fern Valley is a photographic meditation on presence and connection – to time and place, people and animals, the material and ethereal worlds.

In March 2020, amid global crisis, I was invited to Fern Valley along the Soque River in northeast Georgia. I resolved to be generative amid the quietude. With my 8×10-inch-view camera, which supports my contemplative approach, I began a communion with a new family, culture and place. Intuition, light, love and a lifelong spiritual connection to the natural kingdom guided me.

Fern Valley also draws inspiration from 19th-century Spiritualism – which posited that the spirit exists beyond the body and that the spirits of the deceased communicate with the living – and from transcendental philosophy, which asserts that nature is formed by spirits.

Janelle Lynch, born in 1969, is an American artist living in New York, United States, whose work explores themes of connection, presence and transcendence. Her photographs are in many private and public collections, including the Metropolitan Museum of Art, New York, and the Victoria and Albert Museum, London. She has had three books published.

p98 ALICE MANN

These images depict the unique aspirational subculture surrounding all-female teams of drum majorettes in South Africa, affectionately known as 'drummies'. Their sport became popular in the country in the early 1980s. Participation has since dropped dramatically, but in many marginalised communities the sport is highly competitive and being a drummie offers girls a sense of belonging and self-worth.

This is part of my ongoing work exploring notions of femininity and empowerment. I hope these images communicate the pride and confidence achieved by these drummies, who face many social challenges. I want these images to serve as testament to the determination of these young female athletes in a world where so many sporting opportunities are still focused on men.

Alice Mann, born in 1991, is a South African photographic artist who explores picture-making as an act of collaboration. Her work has been exhibited in London, Amsterdam, Addis Ababa, New York and Paris. It has appeared in publications including The New Yorker, *the* British Journal of Photography *and* National Geographic. *Her series* Drummies *has won numerous prizes.*

p99 SOLANGE ADUM ABDALA

My project, *The Conversion of the Trace*, changes our perception of nature by altering the essential chemical components of the analogue image, moving it away from its traditional role of representation. In this way, the photographic process becomes an analogy for climate change – where the material nature of the planet, as well as our perception of it, have been changed by human intervention since the start of the Anthropocene epoch. The title of the project is my name for the process: it begins with chromogenic prints treated with bleach, which generates a visual void and creates new opportunities for the landscape to appear in forms that are surreal, fantastical, magical and sinister.

Solange Adum Abdala was born in Lima, Peru, in 1980. She began as a photography technician at Centro de la Imagen, Lima, where she later gained her degree. Her awards include first prize at the III Salón de la Fotografía, Lima. Her most recent solo exhibition was held in 2022 at Galería Pública, Lima.

Artist Statements & Biographies

p100 **RUT BLEES LUXEMBURG**

My series *Eldorado Atlas* focuses on my local territory, the 'digital roundabout' of Old Street in London, a scene of intense urban transformation. New corporate developments such as The Atlas Building over one side; the emergent shoots of community and nature, manifested in urban allotments and artist-run spaces, on the other.

Photography plays an important and ambivalent role: it is utilised by developers to create computer-generated visualisations to seduce and sell a version of the future city, displayed in the public space, oscillating between promise and despair.

In my photographs, the image is disrupted by the marks of time – dust and spillages and the glare of urban light. The present, with its material and joyously dirty reality, interrupts the allegory of the future.

Rut Blees Luxemburg was born in Germany and lives in London. She has held numerous exhibitions and her public work Silver Forest *is permanently installed on the façade of Westminster City Hall in London. She created the image for the iconic album cover of* Original Pirate Material *by The Streets. She teaches at London's Royal College of Art.*

© VG Bild-Kunst, Bonn 2022

p101 **ERIKA KOBAYASHI**

She Waited. She waited – for the sacred Olympic flame to come to her city, for its light to illuminate everything. The flame was resurrected, passed from torch to torch from Greece, the land of Olympia, to Nazi Germany. Three years after the Berlin Olympics, the Nazi army invaded, as if following the sacred fire's path – the flames burned all in their path to ashes.

She waited – it was one year later, after the Tokyo Olympics failed to happen. The Japanese Imperial Army marched, flames burning all in their path to ashes.

She waited – the bombs she'd so anticipated ended up dropping on Japan instead, illuminating everything around them as they burned all to ashes. The war ended, but life did not. Torch in hand, men descend into darkness.

Writer and artist Erika Kobayashi was born in 1978 in Tokyo, Japan, where she lives and works. Her internationally exhibited installations enable viewers to re-experience scenes from her writings. Her novel His Last Bow *won the 2022 Japan Sherlock Holmes Club Encouragement Award and was the subject of an exhibition in London.*

p102 **WANDA ORME**

The Salton Sea unfolds over 340 square miles of California desert. Here, 226 feet below sea level, fluids pool. Fed meagrely by agricultural and industrial runoff, the sea cycles through blooms and die-offs of algae and fish. Progressively evaporating and labelled an environmental disaster, the sea gets saltier. This is water in the desert: what makes it most problematic is also what makes it so special. Wetlands on the horizon; pools evaporating. At the shores, everything burns. Blooms of algae photosynthesising in the explosion of their own lives; my heart in the presence of such beauty and in the knowledge that all this may be lost. These photographs are my attempt to preserve the beauty and vitality of this place where blue burns. A warning sign where light ricochets.

Wanda Orme is based in London, United Kingdom. Her work has been exhibited in Europe and North America, and she has twice been nominated for the Prix Pictet. She is also known for site-specific sculptural installations. She has published three books, including Blue on Fire *and* Volcano Songs *in 2021.*

Cover **YVONNE DE ROSA**

As the novelist A. S. Byatt said, 'I do not make pilgrimages to places where writers and artists lived. I read their work and think about their colours and words.' In Pozzuoli in 2022, I held an artist residency with inmates from a juvenile detention centre. My workshops focused on visual education and the possibility of generating dialogue through art and learning, how to listen and respond to others through the medium of photography. During their leave from the centre, the inmates worked as museum guides.

My polyptych *Inquisita* is the visual memory of this experience and my personal dialogue with Artemisia Gentileschi, who lived in the area and whose art is now presented every day by those young guides, who consider her as a role model.

Yvonne De Rosa, born in Naples, Italy, in 1975, now lives there and in London. She has published and exhibited her work widely in the United Kingdom, Italy and Iran. She is Art Director of the non-profit independent space Magazzini Fotografici, Naples.

Prix Pictet

Women nominated for the Prix Pictet

Africa

Eliane Aïsso | Pélagie Akowanou | Héla Ammar | Emmanuelle Andrianjafy | Yto Barrada | Zarina Bhimji | Jodi Bieber | Lien Botha | Halida Boughriet | Angela Buckland | Joana Choumali | Margaret Courtney-Clarke | Gwenn Dubourthoumieu | Jillian Edelstein | Sarah Elliott | Bigot Esther | Ymane Fakhir | Fatou Gorbes | Rahima Gambo | Wairimu Gitahi | Gabrielle Goliath | Georgina Goodman | Mouna Jemal | Nikki Kahn | Mouna Karray | Lisa Kahn | Alice Mann | Nancy Mteki | Zanele Muholi | Nobukho Nqaba | Emeka Okereke | Adeola Olagunju | Amaka Osakwe | Jo Ractliffe | Fatimah Tuggar | Alexia Webster | Etinosa Yvonne

Asia Pacific

Bani Abidi | Tasfima Akhter | Poulomi Basu | Jhoane Baterna-Pateña | Nana Buxani | Shen Jo Yin | Sunah Choi | Kitty Chou | Heeseung Chung | Xyza Cruz Bacani | Xing Danwen | Maria Luista Carmen David | Karen Dias | Cao Fei | JJ Fernandez | Shiho Fukada | Gauri Gill | Maiko Haruki | Maki Hayashida | Isa (Meng-Chuan) Hori | Ore Huiying | Nozomi Iijima | Aï Iwane | Peiyi Jiang | Jihoan Jung | Mari Katayama | Tomoko Kawai | Takashi Kawashima | Rinko Kawauchi | Hyewon Keum | Tomoko Kikuchi | Kimsooja | Erika Kobayashi | Hyun-Jin Kwak | An-My Lê | Sunmin Lee | Eunjong Lee | Zhang Lijie | Anna Lim | Almagul Menlibayeva | Asako Narahashi | Wawi Navarroza | Rika Noguchi | Momo Okabe | Saysunee Phiwondee | Yan Wang Preston | Tomoko Sawada | Lieko Shiga | Chinky Shukla | Chi Yin Sim | Dayanita Singh | Wei Leng Tay | Yumiko Utsu | Ayesha Vellani | Xiaoxiao Xu | Miwa Yanagi | Yingji Yang | Liana Yang | Yang Yi | Shizuka Yokomizo | Tomoko Yoneda | JeongMee Yoon | Marjorie (MM) Yu | Circle Yuen | Baijun Zhang | Chen Zhen | Sine (Xuan) Zheng | Lanqing Zhu

Europe

Kate Abbey | Myriam Abdelaziz | Lara Abril | Nadja Abt | Heather Ackroyd | Heather Agyepong | Gabriel i Albecarrin | Emily Allchurch | Susana Anágua | Carla Andrade | Malala Andrialavidrazana | Katharine Baker | Barbara Baran | Joan Bardeletti | Mandy Barker | Lisa Barnard | Flora Bartlett | Mari Bastashevski | Letizia Battaglia | Ute Behrend | Valérie Belin | Camille Brunah | Ursula Biemann | Viktoria Binschtok | Marianne Bjørnmyr | Rut Blees Luxemburg | Melanie Bonajo | Sian Bonnell | Silvia Bigolin | Julie Boserup | Sonja Braas | Polly Braden | Lucie Brodbeck | Elina Brotherus | Vanja Bucan | Jessa Bontes | Stéphanie Buret | Peggy Buth | Daya Cahen | Carlotta Cardana | Adeline Care | Renée Chabot | Anna Cherednikova | Elena Chernyshova | Gayle Chong Kwan | Anna Clarén | Catherine Claude | Hannah Collins | Laure Criqui | Jessica Crombie | Gabriella Csoszó | Maja Daniels | Marije De Haas | Floriane de Lassée | Camila de Maffei | Cristina de Middel | Monica de Miranda | Paola De Pietri | Yvonne De Rosa | Veronique de Viguerie | Sanne De Wilde | Erica Deeman | Agnes Denes | Susan Derges | Benedicte Desrus | Chloe Dewe Mathews | Agnes Dherbeys | Paola di Pietri | Andrea Diefenbach | Rineke Dijkstra | Nicola Dill | Anna Dobrovolskaya-Mints | Alicja Dobrucka | Patricia Dorzel | Claudine Doury | Liza Dracup | Kateřina Držková | Daniela Edburg | Sophie Elbaz | Juliette-Andréa Elie | Tina Enghoff | Ágnes Eperjesi | Krisztina Erdei | Hania Farrell | Alexandra Fazzina | Christiane Feser | Anna Filipova | Giorgia Fiorio | Monika Fischer | Joan Fontcuberta | Justine Foord | Anna Fox | Melanie Friend | Johanna-Maria Fritz | Julia Fullerton-Batten | Marina Gadonneix | Katharina Gaenssler | Marion Gambin | Eli Garmendia | Emily Garthwaite | Matilde Gattoni | Jean Gaumy | Karolina Gembara | Agnès Geoffray | Sophie Gerrard | Simona Ghizzoni | Andrea Gjestvang | Margarita Gluzberg | Chiara Goia | Catharina Gotby | Noemie Goudal | Nathalie Grenzhaeuser | Saskia Groneberg | Julia Gröning | Lola Guerrera | Maïmouna Guerresi | Beate Gütschow | Léa Habourdin | Sigune Hamann | Léonie Hampton | Nanna Hänninen | Bevi Hannula | Cig Harvey | Jacqueline Hassink | Zoe Hatziyannaki | Sabine Haubitz + Stefanie Zoche | Kim Haughton | Nanna Heitmann | Lucy Helton | Laura Henno | Ildi Hermann | Liz Hingley | Kate Holt | Martina Hoogland Ivanow | Laura Hospes | Pepa Hristova | Lucie Jean | Sarah Jones | Marie Jou Sol | Dragana Jurišić | Sanna Kannisto | Annette Kelm | Barbora Kleinhamplová | Maren Klemp | Steffi Klenz | Herlinde Koelbl | Katrin Koenning | Uta Kögelsberger | Aglaia Konrad | Paulina Korobkiewicz | Susanne Kriemann | Anouk Kruithof | Miira Laurila | Marie Le Mounier | Chrystel Lebas | Eva Leitolf | Clara Lebeck

Szilagyi Lenke | Namsa Leuba | Julia Lisnyak | Emma Livingston | Dana Lixenberg | Bettina Lockemann | Adriana Lopez Sanfeliu | Vera Lutter | EJ Major | Anna Malagrida | Nina Mananilla | Melanie Manchot | Daria Marchik | Raffaela Mariniello | Margarita Mavromichalis | Kate McMillan | Myriam Meloni | Eglė Melynauskienė | Altangul Medillovová | Nadège Mériau | Tamara Merino | Fiona Mersh | Sara Minelli | Hannah Modigh | Noha Mokhtar | Juli Monasov | Yvette Monahan | Melissa Moore | Lena Mucha | Karin Apollonia Müller | Isabel Muñoz | Freya Najade | Tuula Närhinen | Elisabeth Neudorfl | Mame-Diarra Niang | Jackie Nickerson | Simone Nieweg | Lucia Nimcova | Kate Nolan | Katarzyna Novak | Mandy O'Neill | Vivian Olmi | Catherine Opie | Wanda Orme | Liz Orton | Nelli Palomäki | Ewa Pandera | Myrto Papadopoulos | Natasha Pavlovskaya | Beatrice Pediconi | Helena Petersen | Regine Petersen | Sarah Pickering | Birthe Piontek | Francesca Piqueras | Tatiana Plotnikova | Jill Quigley | Inge Rambow | Rosch na Ramisch | Agnieszka Rayss | Lola Reboud | Lotte Reimann | Giada Ripa | Sophie Ristelhueber | Ricarda Roggan | Jana Romanova | Almudena Romero | Pamela Rosenkranz | Flurina Rothenberger | Sasha Rudensky | Nadia Sablin | Lise Sarfati | Zina Saro-Wiwa | Viviane Sassen | Sarah Schönfeld | Anne Schwalbe | Zineb Sedira | Sandra Senn | Indre Serpytyte | Maria Sewcz | Marina Shacola | Corinne Silva | Mona Simon | Senta Simond | Mariah Skellorn | Anna Skladmann | Barbora Šlapetová | Anne-Katrin Spiess | Gaia Squarci | Hannah Starkey | Iren Stehli | Amelia Stein | Gerda Steiner | Anouk Stulens | Eva Stenram | Linder Sterling | Danae Stratou | Lenka Szilagyi | Ingetje Tadros | Maija Tammi | Anastasia Taylor-Lind | Esther Teichmann | Mila Teshaieva | Anna Tihanyi | Berta Tilmantaitė | Danila Tkachenko | Marie Tomanova | Alys Tomlinson | Tessa Traeger | Aurore Valade | Awoiska van der Molen | Hanne van der Woude | Laura Van Severen | Bénédicte Vanderreydt | Clara Vannucci | Brigitte Vaury | Marylise Vigneau | Corinne Vionnet | Anna Voitenko | Ester Vonplon | Naglaa Walker | Ruby Wallis | Johanna Ward | Harley Weir | Róisín White | Alice Wielinga | Jane and Louise Wilson | Vanessa Winship | Catherine Yass | Ksenia Yurkova | Pernilla Zetterman | Alena Zhandarova | Ana Zibelnik | Mylène Zizzo

Latin America

Paola Damaris Acata | Solange Adum Abdala | Gladys Alvarado | Liza Ambrossio | Cláudia Andujar | Adriana Patricia Aridjis Perea | María José Arjona | Nora Aslan | Ananké Asseff | Marlene Bergamo | Karen Paulina Biswell | Erica Bohm | Ángela Bonadies | Marie Ange Bordas | Sofia Borges | Katya Brailovsky | Oleñka Carrasco | Livia Corona | Rochelle Costi | Angélica Dass | Lalo de Almeida | Milagros de la Torre | Paula Dias Leite | Erika Diettes | Dornith Doherty | Luisa Dörr | Sandra Elias | Julieta Escardó | Juanita Escobar | Carolina Figueroa Arango | Tania Franco | Karla Gachet | Verónica Giraldo Canal | Maya Goded | Adela Goldbard | Ana Cecilia Gonzales Vigil | Amada Granado | Lourdes Grobet | Anabell Guerrero | Andrea Hamilton | Norma I. Quintana | Claudia Jaguaribe | Karina Juárez | Lucia Koch | Francisca R. Lake | Isabella Lanave | Suwon Lee | Karla Leyva Leal | Paula Luttringer | Joana Luz | Marcela Magno | Mari Mahr | Anna Maria Maiolino | Ana María Arévalo | Mayra Martell | Alice Martins | Elsa Medina | Fabíola Menchelli | Cristina Mittermeier | Mídia Ninja | Maria Oliveira | Jael Orea | Rosario López Parra | Chantal Peñalosa | Dulce Pinzón | Maria Teresa Ponce | Libia Posada | Rosângela Rennó | Camila Rodrigo | Erika Rodriguez | Daniela Rossell | Paula Sampaio | Mara Sánchez Renero | Misha Vallejo | Yvonne Venegas | Carla Verea | Leonora Vicuña | Bárbara Wagner | Ana Werren | Adriana Zehbrauskas

Middle East

Elahe Abdolahabadi | Ebtisam Abdulaziz | Inbal Abergil | Lamia Maria Abillama | Sele Aboutaleb | Sarah Abu Abdallah | Azadeh Akhlaghi | Sara Al Obaidly | Sama Al Shaibi | Jananne Al-Ani | Manal Al Dowayan | Alia Ali | Balqis Alrashed | Sama Alshaibi | Mehrva Arvin | Lara Atallah | Ilit Azoulay | Fatemeh Baigmoradi | Lara Baladi | Hejer Ben Othmen | Lateefa Bint Maktoum | Myriam Boulos | Laura Boushnak | Elinor Carucci | Gohar Dashti | Sinem Dişli | Rena Effendi | Laura El-Tantawy | Liat Elbling | Rana El Nemr | Hala Elkoussy | Clara Gebran | Bennu Gerede | Shadi Ghadirian | Nilbar Güreş | Tanya Habjouqa | Rula Halawani | Joana Hadjithomas | Nermine Hammam | Nashmia Haroon | Anahit Hayrapetyan | Lea Golda Holterman | Sitara Ibrahimova | Lama Kabbani | Mahboubeh Karamli | Zeynep Kayan | Dalia Khamissy | Ghada Khunji | Waheeda Malullah | Rima Maroun | Sara Masinaei | Mahnaz Minavand | Randa Mirza | Sina Momtaheni | Tahmineh Monzavi | Sara Naimpour | Sara Niroobakhsh | Roya Noorinezhad | Katarina Premfors | Maryam Roshanfekr | Jocelyne Saab | Zeinab Saghafi | Zahra Saleki | Randa Shaath | Shirana Shahbazi | Rosaline Shahnavaz | Farahnaz Sharifi | Ahlam Shibli | Sheida Soleimani | Mitra Tabrizian | Golnaz Taheri | Newsha Tavakolian | Hamila Vakili | Karine Wehbé | Pinar Yolaçan | Maya Zack | Lara Zankoul

North America

Lynsey Addario | Jane Fulton Alt | Tina Barney | Marion Belanger | Bremner Benedict | Nina Berman | Nydia Blas | Barbara Bosworth | Anna Boyiazis | Marilyn Bridges | Vanessa Brown | Andrea Bruce | Eszter Burghardt | Renée C. Byer | Kitra Cahana | Vanessa Charlot | Judy Chicago | Christine Collins | Lois Conner | Barbara Davidson | Janet Delaney | Liz Deschenes | Andrea DiCenzo | Jessica Dimmock | Carolyn Drake | Medina Dugger | Melanie Dunea | Lisa Elmaleh | Terry Evans | Donna Ferrato | Samantha Fields | LaToya Ruby Frazier | Dana Fritz | Lauri Garcia Jones | Karen Glaser | Glenna Gordon | Katy Grannan | Lauren Greenfield | Karen Halverson | Allison Janae Hamilton | Sharon Harper | Elizabeth D. Herman | Alexis Hunley | Ayana V. Jackson | Thilde Jensen | Lynn Johnson | Acacia Johnson | Shahrzad Kamel | Dina Kantor | Jennifer Karady | Jan Kassay | Barbara Kasten | Angela Kelly | Asia Kepka | Soo Kim | Cassandra Klos | Karen Knorr | Stacy Kranitz | Barbara Kruger | Nijole Kudirka | Mona Kuhn | Justine Kurland | Norma L. Quintana | Karine Laval | Rita Leistner | Zoe Leonard | Laura Letinsky | Lisa Lindvay | Susan Lipper | Nicole Lloyd | Katherine Lotze | Jessamyn Lovell | Cristina Lucas | Deborah Luster | Janelle Lynch | Holly Lynton | Sally Mann | Diana Markosian | Karen Marshall | Rebecca Martinez | Diana Matar | Mary Mattingly | Meryl McMaster | Laura McPhee | Amanda Means | Mary Beth Meehan | Susan Meiselas | Marilyn Minter | Karen Miranda-Rivadeneira | Yola Monakhov | Haley Morris-Cafiero | Greer Muldowney | Yamini Nayar | Lori Nix | Elin O'Hara Slavick | Jenny Odell | Lisa Oppenheim | Darcy Padilla | Lydia Panas | Cara Phillips | Colleen Plumb | Alex Prager | Emily Price | Norma I. Quintana | Susana Raab | Carla Rippey | Judith Joy Ross | Erika P. Rodríguez | Victoria Sambunaris | Anastasia Samoylova | Alessandra Sanguinetti | Carrie Schneider | Dona Schwartz | Camille Seaman | Christina Seely | Christine Shank | Jennifer Shaw | Lauren Shaw | Nadia Shira Cohen | Anna Shteynsleger | Laurie Simmons | Taryn Simon | Stephanie Sinclair | Savannah Spirit | Andrea Star Reese | Amy Stein | S. Gayle Stevens | Channell Stone | Zoe Strauss | Lida Suchy | Joan Sullivan | Louisa Marie Summer | Rachel Sussman | Nye' Lyn Tho | Diana Thorneycroft | Penelope Umbrico | Ami Vitale | Lisa Wiltse | Katherine Wolkoff | Bahar Yürükoğlu | Yelena Zhavoronkova

Oceania

Ying Ang | Donna Bailey | Caryline Boreham | Megan Bowers-Vette | Aletheia Casey | Odette Cavill | Peta Clancy | Karen Crisp | Judith Crispin | Brenda L. Croft | Zoë Croggon | Nici Cumpston | Rebecca Dagnall | Ruby Davies | Marian Drew | Sarah Ducker | Odette England | Anne Ferran | Kate Geraghty | Siri Hayes | Megan Jenkinson | Rosemary Laing | Jess MacNeil | Claire Martin | Belinda Mason | Georgia Metaxas | Julie Millowick | Rachel Mounsey | Nasim Nasr | Tracey Nearmy | Anne Noble | Susan Norrie | Lillian O'Neil | Selina Ou | Fiona Pardington | Lyndal Petzke | Jackie Ranken | Kate Robertson | Raphaela Rosella | Ann Shelton | Julie Shiels | Kiki Sjoberg | Valerie Sparks | Rebecca Swan | Yvonne Todd | Stephanie Valentin | Ans Westra | Anne Zahalka

Prix Pictet

Jury members – All cycles

Shahidul Alam
Photographer, activist and Director of
Pathshala South Asian Media Institute, Dhaka
Growth

Benoit Aquin
Photographer
Winner, Prix Pictet *Water*
Earth

Peter Aspden
Arts Writer, *Financial Times* 2005–20
Water, Growth, Consumption, Disorder

Martin Barnes
Senior Curator of Photographs,
Victoria and Albert Museum, London
Disorder, Space, Hope

Valérie Belin
Photographer
Winner, Prix Pictet *Disorder*
Space

Philippe Bertherat
President
Musée d'Art moderne et contemporain,
Geneva
Disorder, Space, Hope, Fire

Edward Burtynsky
Photographer
Disorder

Joana Choumali
Artist
Winner, Prix Pictet *Hope*
Fire

Jan Dalley
Arts Editor, *Financial Times*
Earth, Power, Space, Hope

Emmanuelle de l'Ecotais
Curator of Photography, Musée d'Art
moderne de la Ville de Paris 2001–18
Disorder, Space

Luc Delahaye
Photographer
Winner, Prix Pictet *Power*
Consumption

Régis Durand
1941–2022
Writer and art critic
Head of the Jeu de Paume 2003–06
Water

Mitch Epstein
Photographer
Winner, Prix Pictet *Growth*
Power

Shahira Fahmy
Founder and Principal
Shahira Fahmy Architects, Cairo
Fire

Duncan Forbes
Director of Photography
Victoria and Albert Museum, London
Fire

Michael Fried
Art critic and historian
Growth, Power

Nili Goren
1965–2016
Curator of Photography
Tel Aviv Museum of Art
Disorder

Dame Zaha Hadid
1950–2016
Founder
Zaha Hadid Architects
Earth

Francis Hodgson
Professor in the Culture of Photography
University of Brighton
Chair: *Water, Earth*

Herminia Ibarra
Charles Handy Professor of Organisational
Behaviour, London Business School
Hope, Fire

Leo Johnson
Co-Founder, Sustainable Finance
and Head of Disruption & Innovation, PwC
United Kingdom
Water, Power

Nadav Kander
Photographer
Winner, Prix Pictet *Earth*
Growth

Abbas Kiarostami
1950–2016
Film director, screenwriter, poet,
photographer and film producer
Water

Sir David King, FRS
Founder and Chair
Centre for Climate Repair at Cambridge
Earth
Chair: *Growth, Power, Consumption,*
Disorder, Space, Hope, Fire

Christine Loh
Co-founder and CEO
Civic Exchange
Growth

Richard Misrach
Photographer
Water

Richard Mosse
Photographer
Winner, Prix Pictet *Space*
Hope

Dambisa Moyo
Global economist and author
Space

Fumio Nanjo
Curator and art historian
Director
Mori Art Museum, Tokyo 2006–20
Earth, Growth, Power, Consumption

Loa Haagen Pictet
Head of Arts, Chief Curator
Collection Pictet
Water, Earth, Growth, Power, Consumption

Jeff Rosenheim
Joyce Frank Menschel Curator
in Charge of Photographs
The Metropolitan Museum of Art, New York
Hope, Fire

Martin Roth
1955–2017
Director
Victoria and Albert Museum 2011–16
Power, Consumption

Sebastião Salgado
Photographer
Space

Kazuyo Sejima
Co-Founder
SANAA Architects
Hope

Wang Shu
Architect
Consumption, Disorder, Space

Elisabeth Sussman
Curator and Sondra Gilman Curator of
Photography, Whitney Museum of American Art,
New York
Consumption, Disorder

Prix Pictet

Nominators

Africa

Roger Ballen | Rory Bester | Raphael Chikukwa | Medina Dugger | Christine Eyene | John Fleetwood | Joseph Gergel | Véronique Joo Aisenberg | David Knaus | Stephan Köhler | Thierry Konarzewski | Michket Krifa | Nadira Laggoune | Jeanne Mercier | Azu Nwagbogu | Ugochukwu-Smooth C. Nzewi | Oluremi Onabanjo | Sean O'Toole | Rachida Triki | Roelof van Wyk

Asia Pacific

Shahidul Alam | Rahaab Allana | Bérénice Angremy | Françoise Callier | Christian Caujolle | Joselina Cruz | Brian Curtin | Devika Daulet-Singh | Nathaniel Gaskell | Shigeo Goto | Yumi Goto | NayanTara Gurung Kakshapati | Salima Hashmi | Shinichiro Ito | Wang Jun | Michiko Kasahara | Shiho Kito | Bohnchang Koo | Eyal Landesman | Gwen Lee | Jiyoon Lee | Kevin WY Lee | Szewan Leung | Ryan Libre | Yusuke Nakanishi | Jean-Yves Navel | Elaine Ng | Lu Ni | Harumi Niwa | Naoko Ohta | Lucille Reyboz | RongRong & Inri | Bittu Sahgal | Raz Samira | Liu Heung Shing | Kazuko Sekiji | Farah Siddiqui | Douglas So | Sujong Song | Patrick Sun | Shane Suvikapakornul | Mariko Takeuchi | Eugene Tan | Rudy Tseng | Harsha Vadlamani | Ivan Vartanian | Belinda Winterbourne | Tang Xin | Yuko Yamaji | Yan-Yan Yip | Duan Yuting | William Zhao | Li Zhenhua

Europe

Alia Al-Senussi | Carol Allen-Storey | Monica Allende | Lisa Anderson | Béatrice Andrieux | Regina Maria Anzenberger | Karin Askham | Gerry Badger | Quentin Bajac | Simon Baker | Arnis Balčus | Sheyi Bankale | Christine Barthe | Anne-Marie Beckmann | Sophie Bernard | Ana Berruguete | Tobia Bezzola | Daniel Blochwitz | Daria Bonera | Thomas Borberg | Enrico Bossan | Bruno Boudjelal | Sophie Boursat | Anne-Marie Bouttiaux | Emma Bowkett | Krzysztof Candrowicz | Chiara Capodici | Jim Casper | Alejandro Castellote | Zelda Cheatle | Hans D. Christ | Zoë Christensen | Tim Clark | Dirk Claus | Charlotte Cotton | Jess Crombie | Luc Debraine | Marco Delogu | Richard Duebel | John Duncan | Florian Ebner | Maryam Eisler | Brandei Estes | Chantal Fabres | Louise Fedotov-Clements | Marcel Feil | Eva Fisli | Andrzej P. Florkowski | Valérie Fougeirol | Lena Fritsch | Benjamin Füglister | Tamar Garb | William Gilchrist | Marta Gili | Arno Gisinger | Adam Goff | Anna Gripp | Francois Hebel | Francis Hodgson | Felix Hoffmann | Genevieve Janvrin | Alain Jullien | Mindaugas Kavaliauskas | Magda Keaney | Klaus Kehrer | Hester Keijser | Sarah Kenderdine | Tanya Kiang | Oliver Kielmayer | Simone Klein | Fabian Knierim | Marloes Krijnen | Evelien Kunst | Laurence Lagrange | Trish Lambe | Bettina Leidl | Sylvain Lévy | Harriet Logan | Vicky Long | Tristan Lund | Celina Lunsford | Michael Mack | Francesca Malgara | Alvaro Matias | Shoair Mavlian | Rebecca McClelland | Seamus McGibbon | Vera Michalski-Hoffmann | Antonio Molina-Vázquez | Manolis Moresopoulos | Anne Morin | Walter Moser | Nat Muller | Andreas Müller-Pohle | Yasufumi Nakamori | Philippa Neave | Moritz Neumüller | Simon Njami | Laura Noble | Christine Ollier | Silvia Omedes | Alona Pardo | Nina Pearlman | Timothy Persons | Katrin Peters-Klaphake | Benedict Philpott | Fiorenza Pinna | Ulrich Pohlmann | Michael Pritchard | Phillip Prodger | Lou Proud | Marc Prüst | Véronique Rautenberg | Ann Ray | Yasmina Reggad | Karin Rehn-Kaufmann | Nuno Ricou Salgado | Julian Rodriguez | María Inés Rodríguez | Brett Rogers | Mario Rotllant | Ida Ruchina | Verónica Sanchis Bencomo | Mario Santoro | Torsten Scheid | Carrie Scott | Thomas Seelig | Laura Serani | Fiona Shields | Tamsin Silvey | Karen Smith | Carla Sozzani | Enrico Stefanelli | Bernd Stiegler | Stefano Stoll | Sam Stourdzé | Roger Szmulewicz | Ingo Taubhorn | Anna Tellgren | Juha Tolonen | Nanda van den Berg | Wim van Sinderen | Enrica Viganò | Dragana Vujanovic | Jean Wainwright | Artur Walther | Jeni Walwin | Nadine Wietlisbach | Demet Yildiz | Gu Zheng

Latin America

Marcelo Araújo | Fernando Arias | Gustavo Artigas | Daniel Brena | Alejandro Castellanos | Ramón Jiménez Cuen | Sofía Dourron | Elvis Fuentes | Tom Griggs | Roberto Huarcaya | Jessica Hubbard Marr | Nicola Maffei | Tobi Maier | Antigoni Memou | Mayu Mohanna | John Mraz | Elena Navarro | Thyago Nogueira | Gonzalo Olmos | Karla Osorio | Nelson Ramírez de Arellano Conde | Manuel Rivera-Ortiz | José Roca | Itala Schmelz | Clara de Tezanos | Itzel Vargas Plata | Ricardo Viera | Luis Weinstein | Trisha Ziff

Middle East

Basma Al Sulaiman | Peggy Sue Amison | Maya Anner | Myriem Baadi | Sena Çakirkaya | Levent Çalıkoğlu | Simindokht Dehghani | Fariba Derakhshani | Elie Domit | Anahita Ghabaian Etehadieh | Shadi Ghadirian | Tami Gilat | Giles Hudson | Isabella Icoz | G. H. Rabbath | Somayeh Rokhgireh and Ali Pooladi | Khaled Samawi | Maria Sukkar | Sinem Yoruk

North America

Peter D. Barberie | Elisabeth Biondi | Jennifer Blessing | Phillip Block | Gail Buckland | Joshua Chuang | Joerg Colberg | T.J. Demos | Natasha Egan | Steven Evans | William A. Ewing | Elizabeth Ferrer | Merry Foresta | David Griffin | Richard & Ronnie Grosbard | Virginia Heckert | Darius Himes | W. M. Hunt | Karen Irvine | Corey Keller | Deborah Klochko | Adriana Teresa Letorney | Lesley A. Martin | Stephen Mayes | Michael Mehl | Cristina Mittermeier | Kevin Moore | Rebecca Morse | Alison Nordstrom | Erin O'Toole | November Paynter | Jaime Permuth | Sandra S. Phillips | Drew Sawyer | Jillian Schultz | Paula Tognarelli | Sofia Vollmer de Maduro | Sophie Wright

Oceania

Paola Anselmi | Daniel Boetker-Smith | Rebecca Chew | Maggie Finch | Helen Frajman | Jennifer Higgie | Natalie King | Julie Millowick | Pippa Milne | Jeff Moorfoot | Isobel Parker Philip | Anouska Phizacklea | Elias Redstone | Heidi Romano | Moshe Rosenzveig | Geoffrey Short | Christine Tomas

Prix Pictet exhibitions

London
Mall Galleries
Water 2009
Diemar/Noble Gallery
Earth 2010
Saatchi Gallery
Power 2012
Somerset House
Commissions 2013
Disorder 2016
Victoria and Albert Museum
Consumption 2014
Space 2017
Hope 2019
Fire 2021

Brussels
CAB Art Centre
Consumption 2015
Disorder 2016
Space 2018

Monaco
Grimaldi Forum
Hope 2021

Amsterdam
Huis Marseille
Power 2013

Saint-Paul-de-Vence
Fondation CAB
Fire 2022

Dublin
Gallery of Photography
Earth 2010
Growth 2011/12
Power 2013
Consumption 2015
Disorder 2017/18
Space 2018/19
Hope 2020

Luxembourg
Ratskeller
Consumption 2014

Washington D.C.
Corcoran Gallery of Art
Growth 2011

Paris
Palais de Tokyo
Water 2008
Passage de Retz
Earth 2009
Growth 2010
Galerie Les Filles du Calvaire
Growth 2010
Galerie Vanessa Quang
Power 2012
Musée d'Art moderne
Disorder 2015

Stuttgart
House of Economy
Space 2018

Rome
MAXXI Museum
Disorder 2016

Turin
Fondazione Sandretto
Re Rebaudengo
Consumption 2014
CAMERA
Space 2018

New York
Aperture Foundation
Power 2013/14
Flowers Gallery
Space 2018

San Diego
Museum of Photographic Arts
Laureates 2011/12
Power 2014
Disorder 2017

Mexico City
Museo Nacional de Arte
Consumption 2014/15
Museo de Arte Moderno
Space 2018
Fire 2022

Arles
Les Rencontres d'Arles
Laureates 2014
Laureates 2018

Madrid
Delegación Principado
de Asturias
Earth 2010
Real Jardín Botánico
Growth 2011/12

Lucca
Photolux Festival
Space 2017

Geneva
Bâtiment des Forces Motrices
Water Commission 2009
The International Red Cross
and Red Crescent Museum
Disorder 2016

Milan
Fondazione FORMA
Earth 2010
Fondazione Sozzani
Growth 2011
Hope 2021

Barcelona
Palau Robert
Consumption 2014
Disorder 2017

Verona
Palazzo della Gran Guardia
Hope 2021

Hamburg
Kunstverein
Disorder 2016/17

Rossinière
Alt.+1000 Festival
Power Commission 2013

Eindhoven
University of Technology
Water 2009
Earth 2010
Growth 2012

Dresden
Kempinski Hotel
Water 2009
Residenzschloss
Water Commission 2009

Bonn
Sustainability Congress
Water Commission 2009
Earth 2010

Dusseldorf
Arteversum
Growth 2011

Munich
Bernheimer Fine Art Photography
Power 2012
Consumption 2014

Berlin
Caprice Horn Gallery
Earth 2010

Moscow
Moscow House of Photography
Earth 2010
Mouravieff-Apostol House & Museum
Laureates 2016
Space 2018
Hope 2020

Budapest
Hungarian House of Photography
Power 2013

Zurich
Galerie Christophe Guye
Growth 2011
LUMA Westbau
Power 2013
Consumption 2014
Disorder 2016
Space 2017
Hope 2020
Fire 2022

Lausanne
Musée de l'Elysée
Laureates 2010
EPFL ArtLab
Space 2018
Hope 2020
Fire 2022

Beijing
Today Museum
Hope 2021

Istanbul
Istanbul Modern
Power 2013
Global Art Centre
Space 2018

Shanghai
Shanghai Center
of Photography
Hope 2021

Beirut
Ayyam Gallery
Growth 2012
Beirut Exhibition Centre
Power 2013
Consumption 2015

Hong Kong
The Rotunda
Water 2009
Hong Kong Convention
and Exhibition Centre
Growth 2012
Asia Society
Fire 2023

Tel Aviv
Artstation Gallery
Power 2013
MUZA – Eretz
Israel Museum
Hope 2021

New Delhi
Religare Art Gallery
Earth 2010

Athens
The Municipal Gallery
of Athens
Disorder 2016
Athens Conservatoire
Fire 2022

Singapore
School of the Arts
Fire 2023

Dubai
Dubai International Financial Centre
Water 2008
The Empty Quarter Gallery
Earth 2010
East Wing
Consumption 2015
Alserkal Avenue
Fire 2022

Tokyo
Ba-Tsu Art Gallery
Consumption 2015
Bank Gallery
Disorder 2016
Hillside Forum
Space 2017
Prix Pictet Japan 2018
Hope 2019
Tokyo Photographic Art Museum
Fire 2021

Thessaloniki
Thessaloniki Museum of Photography
Water 2008/09
Earth 2009/10
Growth 2011
Power 2013
NOESIS Science Center and Technology Museum
Consumption 2014

water
Paris — Dubai — Thessaloniki — London —
Hong Kong — Eindhoven — Dresden

earth
Paris — Thessaloniki — Dubai —
Eindhoven — Dublin — London —
Bonn — Moscow — Berlin — Milan —
Madrid — New Delhi

growth
Paris — Thessaloniki — Zurich — Milan —
Dusseldorf — Madrid — Washington D.C. —
Dublin — Beirut — Eindhoven — Hong Kong

power
London — Munich — Paris — Budapest —
Istanbul — Dublin — Amsterdam — Beirut —
Thessaloniki — Zurich — London —
Tel Aviv — New York — San Diego

consumption
London — Barcelona — Thessaloniki —
Turin — Zurich — Luxembourg — Munich —
Mexico City — Dubai — Brussels — Dublin —
Beirut — Tokyo

disorder
Paris — London — Rome — Brussels —
Geneva — Zurich — Athens — Tokyo —
Dublin — Hamburg — San Diego — Barcelona

space
London — Zurich — Lucca — Tokyo —
Moscow — Stuttgart — Mexico City —
Turin — Brussels — Lausanne — Istanbul —
New York — Dublin

hope
London — Tokyo — Zurich — Moscow —
Lausanne — Verona — Tel Aviv — Monaco —
Shanghai — Dublin — Milan — Beijing

fire
London — Tokyo — Zurich — Lausanne —
Athens — Saint-Paul-de-Vence — Dubai —
Mexico City — Hong Kong — Singapore

laureates
Lausanne — San Diego — Arles —
Moscow — Arles

commissions
Dresden — Bonn — Geneva —
Rossinière — London

PRIX PICTET

Prix Pictet Ltd
Moor House
120 London Wall
London EC2Y 5ET
United Kingdom

Prix Pictet Secretariat
Candlestar
Somerset House
Strand
London WC2R 1LA
United Kingdom
www.prixpictet.com

Image Section – Captions (pages 19 to 102)
For the most part the captions in this section are taken from the artists' statements and in most cases are a direct quotation.

Printed by Wilco Art Books Netherlands, Amersfoort
Made in the Netherlands

Published by gestalten, Berlin 2022
ISBN 978-3-96704-085-2

© Die Gestalten Verlag GmbH & Co. KG, Berlin 2022

For more information, and to order books, please visit www.gestalten.com

Bibliographic information published by the Deutsche Nationalbibliothek.
The Deutsche Nationalbibliothek lists this publication in the Deutsche Nationalbibliografie; detailed bibliographic data is available online at www.dnb.de

Executive Editor
Isabelle von Ribbentrop

Editors
Michael Benson
Georgia Brown

Guest Editor
Fiona Shields

Editorial Advisers
Stephen Barber
Rosario Lebrija Rassvetaieff

Editorial Assistants
Fariba Farshad, Roberta Genovese
and Jack Grimston

Editorial Manager
Arndt Jasper

Proofreading
Emma Molloy and Kim Scott

Additional textual review
Havard Davies

Designed by:
Together Design Ltd
67 Orford Road
London E17 9NJ
United Kingdom
E hello@togetherdesign.co.uk
T +44 (0)20 7631 4545
www.togetherdesign.co.uk

This book is typeset in Lardy Sans and Lardy Serif. The pages are printed on Condat Matt Périgord FSC 170g/qm according to the standards of the FSC®.

For all news and updates on the Prix Pictet, please visit our website by scanning this QR Code with your mobile device.